CREATIVE TENSION
BRITISH ART 1900–1950

Stephen Whittle

Adrian Jenkins

Francis Marshall

David Morris

Dinah Winch

Paul Holberton publishing, London

CREATIVE TENSION
BRITISH ART 1900-1950
2005-2006
OLDHAM PRESTON BOLTON ROCHDALE

Gallery Oldham 5 March–2 May 2005
Harris Museum and Art Gallery, Preston 14 May–10 July 2005
Bolton Museum, Art Gallery and Aquarium 23 July–17 September 2005
Touchstones Rochdale 1 October 2005–8 January 2006
Fine Art Society, London 24 January–18 February 2006

First published February 2005
For image copyrights see page 128
Texts copyright © 2005 the authors

ISBN (hardcover) 1 903470 28 5 (softcover) 1 903470 37 4

British Library in Publication Data
A catalogue record for this book is available in the British Library

Designed by Alan Buchanan, Harris Museum and Art Gallery, Preston
Edited by Stephen Whittle, Gallery Oldham

Published by Paul Holberton publishing
37 Snowfields, London, SE1 3SU
www.paul-holberton.net

Printed in Verona, Italy

Back of cover: Solomon Solomon, *An Allegory*; Matthew Smith, *Reflections*;
William Orpen, *Behind the Scenes*; Mark Gertler, *The Bokhara Coat*; John Banting, *Goat Man*

The exhibition is supported by the Esmée Fairbairn Foundation Regional Museums Initiative

Contents

Acknowledgements

The *Creative Tension* book and touring exhibition are part of the Regional Museums Initiative funded by the Esmee Fairbairn Foundation. The support of the Foundation provided a rare and very valuable opportunity for galleries in the North West to research and publish on their historic collections.

The Paul Mellon Centre for Studies in British Art provided additional funding for this publication.

The curators of the exhibition wish to thank everyone who has helped with the preparation of this project, not least the staff of the four participating galleries in Oldham, Preston, Bolton and Rochdale, who made it such an enjoyable experience. Thank you also to the gallery staff in the municipal galleries of Blackburn, Bury, Southport and Blackpool for allowing us to borrow their artworks and for their invaluable assistance, to David Morris and Adrian Jenkins for contributing essays at relatively short notice and to Karl Byrne, research assistant at Gallery Oldham, for all his hard work.

The *Creative Tension* project provided many opportunities for gallery staff across the region to work collaboratively. Hopefully, the opportunity to get to know each other's collections in greater depth will lead to equally productive partnerships in the future.

Introduction

by Stephen Whittle

The history of 'modern art' has become the history of the avant-garde. A persuasively simple aesthetic ideology has developed, characterized as 'institutional modernism',[1] in which modern art is presented as an evolutionary process. This orthodoxy presents art from the time of the Impressionists onwards as a series of 'isms', a progression of 'movements' constantly building on and displacing each other.

The origins of institutional modernism can be traced at least as far back as 1914, to early survey exhibitions of modern art by galleries like the Tate and the Whitechapel, and to the writings of curators and critics such as Clive Bell and Frank Rutter. Since the 1950s, however, it has become the dominant ideology, underpinning and closely defining the general public's understanding of modern art.

As a consequence, modern critical acceptance of British artists working in the first half of the twentieth century has depended very much on the degree to which they can be classified as Vorticist, Post-Impressionist, Surrealist or Abstract. The rest have been dismissed by the champions of modernism, notably Herbert Read, as "the great mass of academic, bourgeois art".[2]

This publication is concerned with the vast wealth of British art produced during a turbulent half-century, reaching from the end of the Victorian era to the beginning of the nuclear age. Much of it falls outside the familiar but narrow and often misleading range of categories with which we have become familiar.

In Britain, attitudes to traditional and modern art were already polarized at the end of the nineteenth century. Despite the large numbers of artists studying and exhibiting on the Continent Impressionism was regarded by many conservative critics and artists as a subversive foreign influence that should be kept on the other side of the Channel. Well before Impressionism was fully assimilated, Roger Fry presented, in 1910 and 1912, ground-breaking exhibitions of what he labelled 'Post-Impressionist' art. Fry argued that artists should now "... dispense once for all with the idea of likeness to Nature ... and consider only whether the emotional elements inherent in natural form are adequately discovered ...".[3] He and his assistant, Clive Bell, decided who were and who were not 'Post-Impressionists'. Those who were left out, such as Walter Sickert, or refused to sign up for any manifesto other than their own, like Augustus John, became marginalized by the emerging modernist establishment.

Herbert Read, the most influential critic in the inter-war years, adopted an openly antagonistic stance to representational art. Associating traditional art with the sort of reactionary politics that had led to the First World War, he asserted that abstraction was necessarily a revolutionary art form, presenting Ben Nicholson and Henry Moore as "... the true revolutionary artists, whom every Communist should learn to respect and encourage".[4] Even after Read lost his early zeal for Marxist socialism he continued to provide an intellectual programme for modernism. Read made the case for art appreciation as a necessarily elitist activity, arguing that "The modern work of art ... is only intelligible to the initiated".[5] By mid-century the critical discourse surrounding the work of art had become more significant than the work itself.

Stalwarts of the academic system, led by ultra-conservatives such as Sir Alfred Munnings, argued ineffectively for the broad popular appeal of representational art. Without a unified intellectual programme, however, traditional art was effectively voiceless by the 1950s.

While the work of a handful of modernists, Henry Moore, Barbara Hepworth and Ben Nicholson in particular, attracted state patronage and official honours in the 1940s, many of the artists occupying the middle ground between tradition and modernity slipped from sight. The reputations of artists such as Augustus John and William Orpen were eclipsed. They and many others have since been written out of surveys of the period. Certain artists, such as Mark Gertler or Jacob Epstein, gained a level of acceptance but are only ever represented by a handful of works that fit the modernist canon.

Stanley Spencer, at the forefront of modern art before the First World War, maintained his interest in the human figure and the primacy of the subject. Consequently in 1935 he was dismissed by Clive Bell as "… producing nothing of permanent value".[6] Spencer's critical reputation has survived, but his case is exceptional. William Roberts, who objected very strongly to his own limited place in the official history of Vorticism, described the process by which artists were being written out of the history books as "… the conspiracy of silence".[7]

The following essays refocus attention on the complex range and interaction of artistic styles current in the earlier part of the last century and examine how British artists variously rejected or assimilated successive waves of innovation arising from Europe and America.

A view is taken from the edge, from the perspective of municipal galleries in the North West of England. At one time Lancashire's prosperous textile-producing towns were among the most important patrons of modern art, benefiting from individual benefactors, large endowment funds and generous purchasing budgets. Slow to react to change, regional galleries nevertheless amassed large and very broad-ranging collections of contemporary art.

The taste of Lancashire's municipal collectors is often surprising, reflecting, to begin with, a sense of mission to educate a largely uninformed public but developing along less predictable lines. Although often several years behind the times, some astute purchases were made, with individual galleries acquiring very distinct characteristics.

Early in the century Oldham bought work from the younger artists exhibiting at the New English Art Club, notably Orpen, Rothenstein and Epstein. Rochdale built up an impressive collection of Impressionist paintings, buying key works by George Clausen, John Lavery and Edward Stott, while Bolton Art Gallery acquired a collection of British 'Post-Impressionists' in the 1940s and some outstanding Surrealist paintings in the 1980s. From the 1890s, the Harris Art Gallery in Preston built steadily on its collection of Victorian paintings from the Royal Academy with major pieces by artists of the calibre of Stanley Spencer and Alfred Munnings as well as the most fashionable artists of the day, including James Gunn and G.L. Brockhurst.

The overall character of the region's collections has been greatly influenced by the Contemporary Art Society. Oldham was given an impressive collection of studio pottery in the 1940s and works by emerging modern artists, such as Lucian Freud, Mark Gertler, Roger Fry and Paul Nash, were distributed in significant numbers to Northern galleries. On the whole, regional galleries did not collect avant-garde art as it was produced, preferring to acquire work which, it was believed, would have lasting quality. With the help of later bequests and some judicious 'back-filling', however, our municipal collections can now present a more rounded and truly representative history of British art than we are likely to see in our national institutions.

1. Robert Hughes, *The Shock of the New – Art and the Century of Change*, London (Thames & Hudson) 1993, p. 372.
2. Herbert Read, *What is Revolutionary Art?*, quoted in B. Rea (ed.), *Five On Revolutionary Art*, London (Artists' International Association) 1935, p. 12.
3. Roger Fry, *An Essay on Aesthetics*, quoted in Roger Fry, *Vision & Design*, Harmondsworth (Pelican) 1961, p. 29.
4. Herbert Read, *What is Revolutionary Art?* (see note 2), pp. 11–12.
5. Herbert Read, *The Philosophy of Modern Art*, 1952.
6. Clive Bell, 'What's Next in Art?', *Studio*, April 1935.
7. William Roberts, *Paintings, 1917–1958*, London 1959, Preface.

Turn of the Century

East

Munnings

Russell

Swanwick

Hayllar

Knight

Arnesby Brown

Solomon

Waterhouse

Goscombe John

Reynolds-Stephens

Drury

Orpen

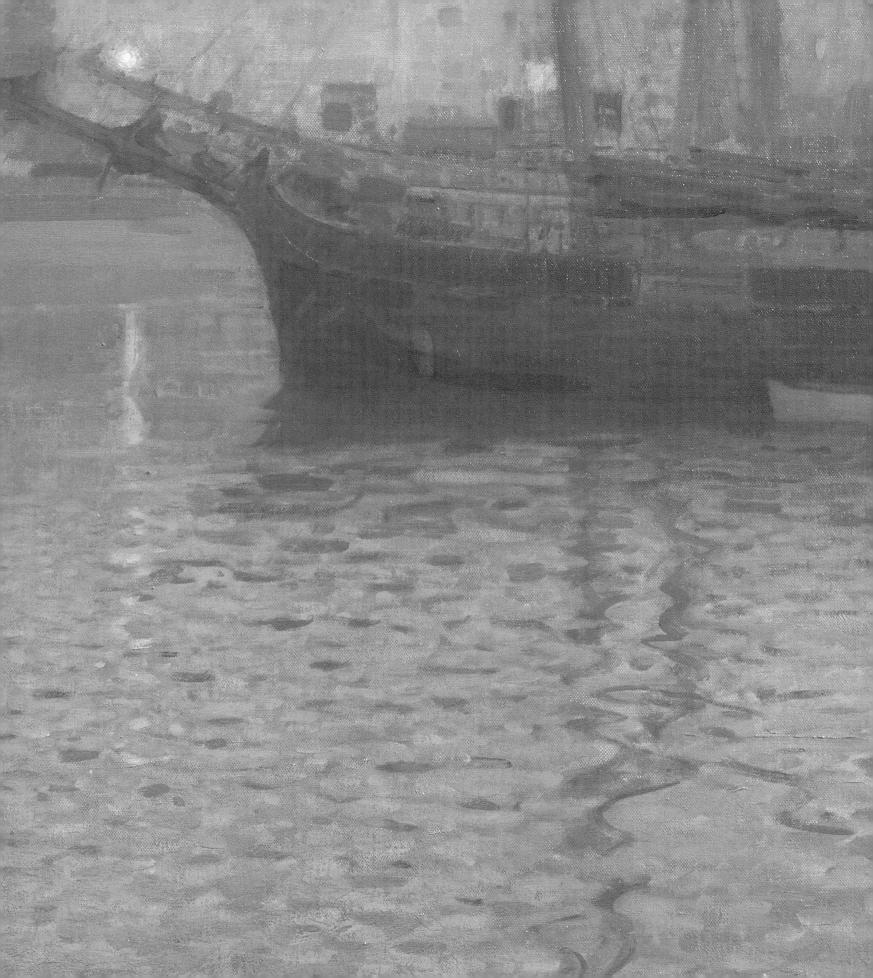

Turn of the Century

by Stephen Whittle

At the beginning of the twentieth century the Royal Academy occupied a pre-eminent position in the British art establishment. The various challenges posed to the academic and craft-based traditions that it represented seemed to have been largely absorbed and contained. There were many dissenting voices, particularly among artists trained in France or at the Slade School of Art and among those working in artists' colonies in Newlyn and St Ives. However, despite its conservatism and deeply entrenched nationalism, the Academy still represented an aspiring artist's best chance of advancement.

Alfred East was the archetype of the successful Edwardian Academy artist. His golden, autumnal landscapes made unashamed reference to the acknowledged masters of the European pastoral tradition. East successfully positioned himself as the inheritor of a native idyllic landscape tradition passed down through the eighteenth-century imitators of Claude Lorraine to Turner and to Constable.

Autumn in the Valley of the Ouse (cat 1), exhibited at the Royal Academy in 1905, is a supremely confident statement about the continuity of artistic tradition. Pre-industrial rural landscapes were a stock feature of the Academy's annual exhibitions throughout the Victorian era. East brought to this tradition a grandiose self-confidence that has its parallel in the music of Elgar, his close contemporary. Bathed in golden autumn sunlight, East's landscape is alive with activity, the figures dwarfed by overarching trees that frame and enfold a serenely untroubled vista.

In his treatise on landscape art of 1906 East exhorts the artist to "… be a man. Stand to your work, and draw and paint from your shoulder in a confident and manly fashion …."[1] Painted in bold masses of light and shade, East's landscapes speak of imperial strength and vigour. Such paintings were enormously popular in England's regional galleries. *Autumn in the Valley of the Ouse* was exhibited and sold at Oldham Art Gallery's 1906 spring exhibition. After an Academy showing East's works were in great demand for municipal galleries' annual exhibitions, notably in Liverpool, Southport, and Preston. Senior Academicians often assisted with the selection of works for regional exhibitions, perpetuating the taste for the tried and tested. As late as 1909 the artist Henry Carr criticized the policy of buying the Academy's 'cast-offs', "… a policy which affirms that the Royal Academy year by year represents the art standard of Europe".[2]

In the early years of the century Alfred Munnings was beginning to make a reputation as a painter of the working agricultural landscape. A future President of the Royal Academy, he would become the most outspoken defender of traditional art in the 1940s. At the heart of his early success as a painter of Norfolk horse fairs and scenes of gypsy life was an appeal to the sense of continuity.

Technically more advanced than East, Munnings employed a personal and very robust form of Impressionism to create a sense of spontaneity that owed something to the example of Jules Bastien-Lepage and the bravura handling of John Singer Sargent, but just as much to his lifelong habit of painting out of doors and his evident passion for country life. *Whitsuntide, a Gala Day* (cat 8), painted in 1902, is a superb example of Munnings's early style. Intense colour notes of red, orange and blue set against a relatively muted background create a scene of bustling activity lit by brilliant sunshine. The effect of a snapshot is heightened by the placement of two children up against the picture-plane, staring directly at the viewer. The relatively sentimental subject-matter of Munnings's *A White Slave* (cat 2) of 1904 is indicative of his attachment to the Victorian tradition of narrative painting. The subject would always be central to Munnings's art, eventually separating him from the more radical trends that were beginning to emerge in Britain.

Munnings's friend the future Academician Laura Knight also launched her career at the turn of the century. *The Fishing Fleet* (cat 6) was painted in the Yorkshire fishing village of Staithes around 1900. This is another image redolent of history and national pride, based in a rural setting little changed by spreading industrial and urban squalor. It is painted in a style that was already becoming dated, however, a form of *plein air* painting popularized by the Hague School of painters in the 1870s. The paint is thick and heavy, the solitary figure of a fisherwoman set against a line of figures pressing stoically towards the shoreline. Knight abandoned the muted tones and rather dour heroism of her Staithes subjects in 1903 to join Stanhope Forbes's colony of artists in Newlyn. Along with Munnings and her husband, Harold Knight, she joined a large group of artists who emulated Jules Bastien-Lepage's use of broad, square brushstrokes and a sharper, cooler tonality applied to large-scale paintings of the figure in a rural setting.

A few miles away from Newlyn at St Ives, a very different tradition had emerged in the late 1880s. John Arnesby Brown's painting *The Harbour* (cat 7) of 1905 owes a clear debt to Whistler, whose advocacy of an aesthetic response to the natural world was in sharp contrast to the breezy naturalism of the Newlyners. *The Harbour* was painted two years after Arnesby Brown had been elected an Associate Royal Academician. This painting, along with Julius Olsson's moonlit nocturnes, illustrates the continuing demand for romantic landscapes in which tonal harmony and overall atmospheric effect were of key importance. However, although they lack any obtrusive narrative element, the St Ives landscapes of Arnesby Brown and Olsson were far less radical than Whistler's nocturnes, as they continued to refer directly to observed experience.

In the sphere of figure painting, William Orpen's career illustrates a gradual drawing together of academic art and what were regarded as some of the more acceptable facets of Impressionism. Orpen exhibited *plein air* landscapes, studies of the model and ambitious conversation pieces at the New English Art Club from 1900, bringing to his work superb qualities of draughtsmanship and a compositional inventiveness based on the close study of Rembrandt, Watteau and Chardin.

Orpen had a very astute understanding of the art market and his place within it. Paintings like *An Eastern Gown* (cat 14) contributed to his reputation as a 'modern', Bohemian artist while making significant concessions to Edwardian taste. This is one of three paintings of Flossie Burnett, a model whom Orpen took from Chelsea to the Metropolitan School of Art in Dublin, where he taught occasionally. All three paintings were shown at the New English Art Club in 1906, where one of them, *A Woman*, attracted heavy criticism both for its very direct sexuality and for the intensity of the lighting, the critic for *The Speaker* complaining that "… a light so bright is unjustified in art".[3] *An Eastern Gown* is less frankly sexual and its capacity to shock a contemporary audience would have been mitigated by the partial draping of the model and the subject's anecdotal qualities.

Walter Russell's *Tying her Shoe* (cat 3) was exhibited at the New English Art Club in 1911. Russell exhibited at both the Royal Academy and the rival New English Art Club in the early part of the century. He was an influential teacher at the Slade School of Art, where Orpen was his pupil, and he later became Keeper of the Royal Academy Schools. *Tying her Shoe* is another painting of a posed model, more demure than *An Eastern Gown* but exhibiting the same awareness of Impressionist innovations. The abruptly cut-off picture frames behind the model, for example, are a Whistlerian device for limiting the spatial focus and emphasizing the two-dimensional plane of the canvas. In its very solid modelling of form, however, and close attention to textural detail, it is far less radical than the work of Whistler or Orpen, reflecting the Edwardian taste for descriptive images of elegance and opulence.

Tying her Shoe was bought for £150 in 1911 from the Oldham Spring Exhibition after being shown at the New English Art Club the year previously. In comparison, the Harris Art Gallery paid the enormous sum of £1240 for Solomon Solomon's *An Allegory* (cat 9) in 1904. Certainly the pictures are very different in scale and ambition, but the difference in price also reflects the high status of mythological and classical paintings well into the twentieth century. From our present-day standpoint Solomon's work seems overblown and, not surprisingly, many of his contemporaries also found it hard to enjoy despite its technical virtuosity. William Rothenstein described Solomon as:

"... an exceptionally capable painter of the big Salon machine. Immoderate labour and skill were, year by year, spent on these immense fabrications, historical, biblical or oriental – signifying little"[4]

The painter of classical genre, Edward Poynter, had been appointed President of the Royal Academy in 1897, re-affirming the institution's inherent traditionalism. Within the realm of classical art, however, artists continued to innovate and to find enthusiastic audiences for their work.

John William Waterhouse was at the height of his career at the turn of the century. He was elected R.A. in 1895 and moved to St John's Wood in 1900, a very fashionable location where he lived among the leading artists of the day. *Psyche entering Cupid's Garden* (cat 10), exhibited at the Royal Academy in 1904, was bought by the Harris Art Gallery in 1907. Following the lead of the Walker Art Gallery in Liverpool and Manchester Art Gallery, the Harris acquired outstanding examples of classicist art, both paintings and sculpture, to adorn its magnificent Greek Revival building.

Waterhouse's brand of classicism was distinct from that of his contemporaries. The narrative qualities of his work were generally more subdued than those of Poynter or Alma Tadema. By the 1890s he had outgrown their interest in archaeological reconstruction and had adapted the aestheticism of Frederic Leighton and Albert Moore to create an evocative dreamworld of his own. Psyche is a central figure in Waterhouse's mature work, a gently melancholic figure representing the journey of the soul.

Soft-focus classicism and an understated form of Symbolism were also important elements in sculpture of the period. Alfred Drury was made an Associate of the Royal Academy in 1900, largely as a result of the popularity of his pieces like *The Age of Innocence* (cat 13). This portrait bust of a friend's child has a gently elegiac quality that was enormously popular at the time.

Drury was part of the movement known as 'the New Sculpture', which grew out of the example of French Salon sculpture in the 1870s. Along with artists like Alfred Gilbert and William Reynolds-Stephens, Drury brought an experimental approach to the use of new materials, introducing flowing, graceful movement and subtlety of

expression to British sculpture. By the early years of the new century, however, the movement had reached its peak. William Goscombe John's *Hermes making his Caduceus* (cat 11) is little more than a re-working of an earlier piece, *Joyance*, a study of youthful movement re-titled and given a few classical attributes. The reactionary quality of some early Edwardian art is also evident in William Reynolds-Stephens's figure of *Guinevere's Redeeming* (cat 12). Multiple versions were made between 1900 and 1907, some encrusted with precious stones and ivory. Although technically daring, works like these took a more literal approach to their source material and offered less in the way of imaginative qualities than the sculpture of the 1880s and 1890s.

The pressure for change within the art establishment gathered pace during the first decade of the twentieth century. Audiences for the Academy's exhibitions dwindled alarmingly between 1900 and 1910,[5] while the New English Art Club, the Glasgow Institute, artist-led exhibiting societies and Roger Fry's exhibitions of Impressionist and Post-Impressionist art all began to alert public and artists to a range of new possibilities. There would be no sudden, dramatic break with the past, however. The First World War brought about a significant reaction against innovation, creating something of a late flowering of representational art. It is against a background of a still vigorous native tradition that the more radical styles of British twentieth-century art would eventually emerge.

1. Alfred East, *The Art Of Landscape Painting in Oil Colour*, London (Cassell) 1906.

2. Henry Carr, *The Autumn Exhibition 1909*, quoted in Anthony Hobson, *The Art & Life of John Waterhouse R.A.*, London (Studio Vista/Christie's) 1980, p. 62.

3. Quoted in *Bruce Arnold, Orpen – Mirror to an Age*, London (Jonathan Cape) 1981, p. 176.

4. William Rothenstein, *Men and Memories*, London and New York 1931, I, p. 35.

5. *The Edwardians and After, The Royal Academy 1900–1950*, London (Weidenfeld & Nicholson) 1988, p.17.

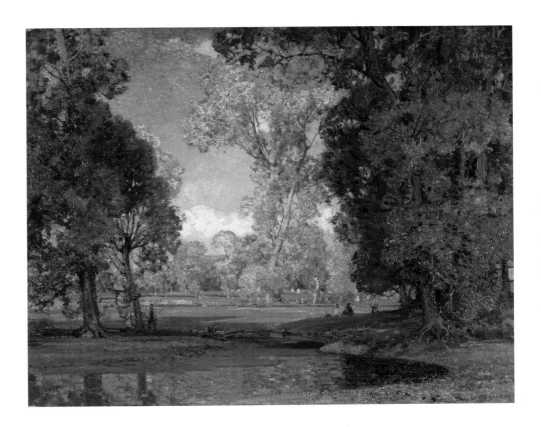

1

Alfred East
(1849–1913)

Autumn in the Valley of the Ouse, 1905
Oil on canvas
121.5 x 151 cm

When East died suddenly in 1913 he was at the height of
his fame. He had recently been made a full Academician
and had been knighted in 1910. He was almost as
popular in America, where he is represented in several
public collections.

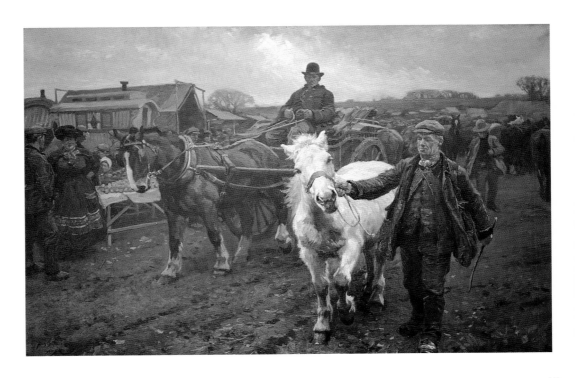

2

Alfred Munnings
(1878–1959)

A White Slave, 1904
Oil on canvas
99 x 150 cm

"My idea when painting it was that the rough low
down hawker fellow has bought the poor old
white pony at the fair and is just off home with it.
Such ponies as we know are slaves and honest
ones too - and as they go down the hill their lot
gets worse" (Undated letter from A.J. Munnings
to W.H. Berry, Gallery Oldham).

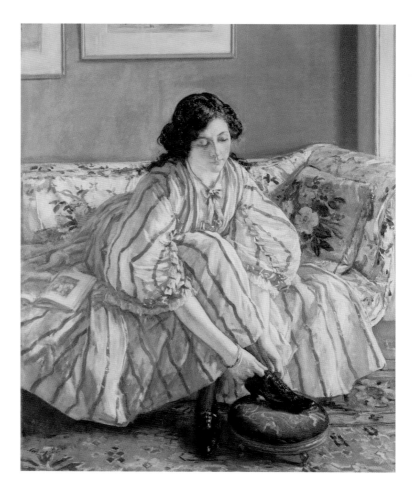

3

Sir Walter W. Russell
(1867–1949)

Tying her Shoe, c.1910
Oil on canvas
93 x 73.5 cm

Though he is now largely overlooked, Russell was a highly successful
artist and an influential teacher. At the Slade School of Art his pupils
included Orpen, John and McEvoy. He was a popular painter of genre,
portraits and Impressionistic landscapes and was made a full
Academician in 1926.

4

Harold Swanick
(1866–1929)

Ducks, 1903-04
Oil on canvas
80 x 59.5 cm

Swanick trained at the Slade School of Art
under Alphonse Legros and admired Millet's
portrayal of rural workers in the landscape. He
was a conservative artist, however, whose rural
idylls had much in common with those of Myles
Birket Foster and Frederick Walker. He last
exhibited pastoral subjects at the Royal
Academy in 1926.

5

Jessica Hayllar
(1858–1940)

There came to my Window, one Morning in Spring, a Sweet Little Robin, 1910
Oil on canvas
40 x 32 cm

The taste for sentimental subject paintings continued well into the twentieth century, and Jessica Hayllar exhibited such work at the Royal Academy right up until 1915. This subject takes on poignancy from the artist's restricted physical circumstances. Following an accident in 1900 she was left unable to walk and painted mainly small-scale still lifes and flower pictures.

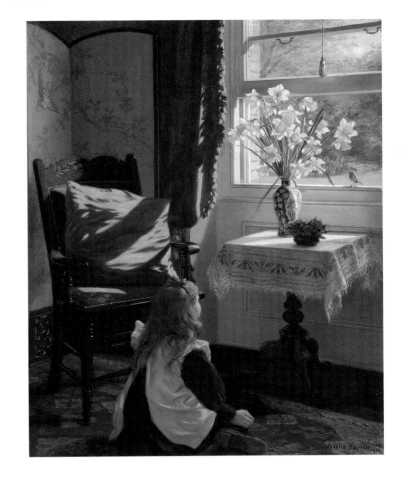

6

Laura Knight
(1877–1970)

The Fishing Fleet, c. 1900
Oil on canvas
122.3 x 81.5 cm

Signed *Laura Johnson*, this picture was painted in Staithes shortly before the artist's marriage to Harold Knight in 1903. Staithes was a relatively small artists' colony, but the Knights knew and made friends with artists such as the Scot Charles Mackie and the Impressionist painter from Oldham Fred Jackson.

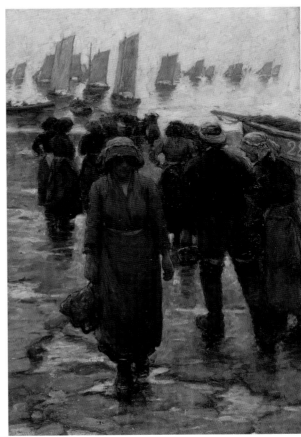

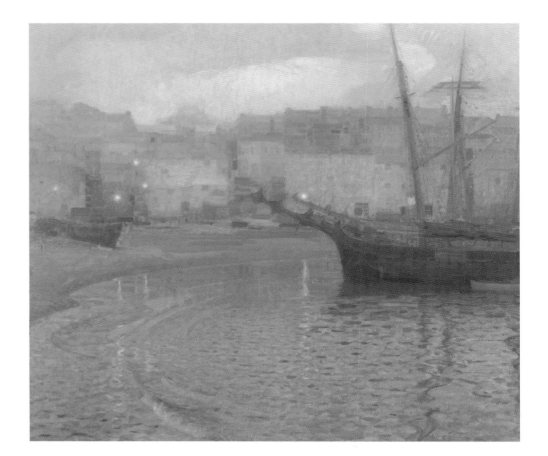

7

John Arnesby Brown
(1858–1940)

The Harbour, 1905
Oil on canvas
92.5 x 105.5 cm

Like Alfred East, Brown made extensive landscape
studies *en plein air*, completing the finished canvases
back in the studio.

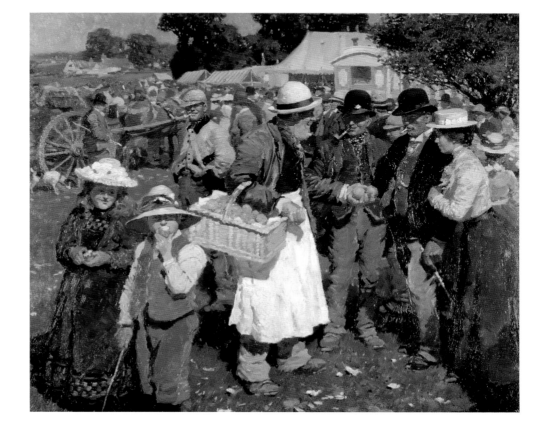

8

Alfred Munnings
(1878–1959)

Whitsuntide, a Gala Day, 1902
Oil on canvas
50.8 x 61 cm

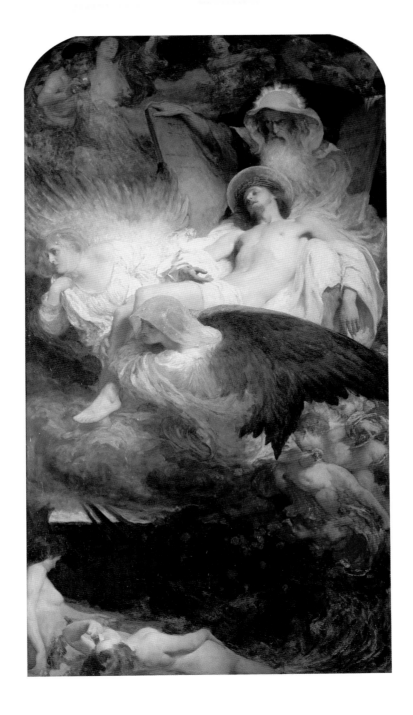

9

Solomon Solomon
(1860–1927)

An Allegory, 1904
Oil on canvas
269 x 150 cm

Solomon was interested in finding the common ground between religions, although his grand symbolic compositions often have an erotic undercurrent. In this painting he included references to Christianity, Judaism and paganism. Christ is borne aloft by angels, behind him the Prophet Moses clutches the tablets of the Commandments. Above are Bacchus, the god of wine, and Venus, the goddess of love, while at the bottom of the composition three naked Sirens lure a passing ship on to the rocks.

10

John William Waterhouse
(1849–1917)

Psyche entering Cupid's Garden, 1903
Oil on canvas
106.7 x 68.5 cm

The story of Psyche was popular with late Pre-Raphaelite artists. Psyche was so beautiful that she aroused the jealousy of the goddess Venus. Cupid was sent to punish her but instead fell in love with her and hid her away in his palace, only ever visiting her at night to preserve his identity. Psyche is pictured stealing into Cupid's garden hoping to catch a forbidden glance of her lover.

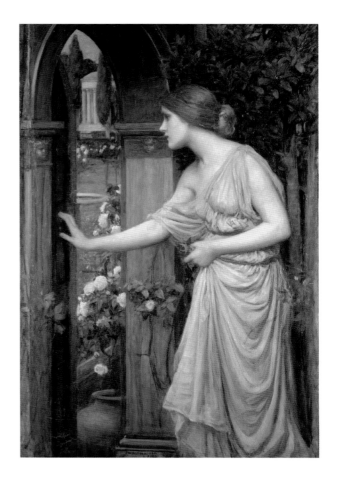

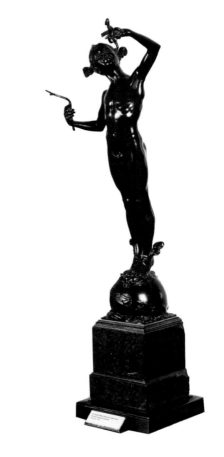

11

William Goscombe John
(1860–1952)

Hermes making his Caduceus, 1904
Bronze
56.2 cm

The figure of Hermes is standing on a globe wearing winged sandals, signifying his role as the god of commerce. He was given a wand, or caduceus, made from an olive branch, with which he is said to have separated two fighting snakes. The entwined snakes became a part of the caduceus, symbolizing Hermes's role as a peacemaker.

12

William Reynolds-Stephens
(1862–1943)

Guinevere's Redeeming, 1905

Bronze

75 cm

Like many sculptors of his generation, including Drury and Goscombe John, most of Reynolds-Stephens's work lay in portrait commissions, memorials and architectural decoration. *Guinevere's Redeeming* is one of a number of subjects he took from Arthurian legend.

13

Alfred Drury
(1856–1944)

The Age of Innocence, 1903

Marble

67.5 cm

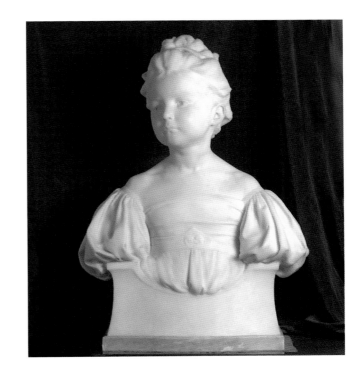

14

William Orpen
(1878–1931)
An Eastern Gown, 1900
Oil on canvas
89 x 73.5 cm

Impressionism in Britain

Connard

Fidler

La Thangue

Clausen

Homel

Pissarro

Lavery

Stott

Osborne

Hall

Impressionism in Britain

by Adrian Jenkins

Impressionism, as derived from French sources, arrived late in Britain. Whilst the critical acceptance of Impressionism in France can be clearly charted during the last quarter of the nineteenth century, in Britain it was the Grafton Galleries' 1905 exhibition of French Impressionist paintings that first gave the movement serious appreciation.[1] Although works by French Impressionist painters had been on view at Durand-Ruel's London gallery from the 1870s, the media's response had varied between tepid interest and indignation, and British painters in general had been diffident rather than enthusiastic.

A significant group of artists involved in the British interpretation of Impressionism belonged to the generation from which emerged the leading British exponents of the European rustic naturalist school from the late 1870s. These included George Clausen, Henry La Thangue, Edward Stott, Fred Hall and John Lavery. Artists such as these had typically worked in France and been influenced primarily, not by the Impressionists proper, but by the practice of painting *en plein air* exemplified by Jules Bastien-Lepage.

Bastien's reputation was based on what immediate contemporaries regarded as his modern and progressive depiction of peasants in rustic landscape settings. Widely acclaimed for their scientific objectivity, technical virtuosity and innovative compositional methods, Bastien's pictures revealed a knowledge and understanding of contemporary photographic techniques, combined in parts with an Impressionist handling of paint. What also impressed contemporaries was Bastien's advocacy of producing his meticulously handled canvases, often large-scale, totally out-of-doors (*en plein air*) rather than in the studio.

During the 1880s and into the 1890s, Clausen, La Thangue and others had experimented with Bastien's repertoire, before eventually recognising its limitations as Impressionism began to filter into the mainstream. United by their dissatisfaction with the standards of the Royal Academy, they founded the New English Art Club in 1886. In 1889, however, the Club came under the control of a minority group led by the avant-garde Walter Sickert, who was interested in both Whistler's aestheticism and French Impressionism, particularly Monet and Degas, and was a harsh critic of Bastien-Lepage.

In 1892 Sickert lambasted Bastien-Lepage and his supporters, complaining of their methods in these terms:

"The sun moves too quickly. You find that grey weather is more possible, and end up by never working in any other, grouping with any approach to naturalness is found to be almost impossible. You find that you had better confine your composition to a single figure. And, with a little experience, the photo realist finds … that the single figure had better be in repose. Even then your picture necessarily becomes a portrait of a model posing by the hour."[2]

By the time Sickert's tirade was published Bastien-Lepage had been dead for eight years. Sickert's criticism was chiefly levelled at the rural naturalists, essentially complaining that their paintings, by competing so closely with photography, were valueless, when what was required was Impressionism's emphasis on the process of paint application, on the study of light, on experimentation and on their challenge to what constituted a truly 'finished' picture.[3]

As the new century dawned, Bastien's style now elicited less contentious debate than previously. Both Clausen and La Thangue's work, in particular, continued to be compared with that of the French master, but both artists had, in the course of the 1890s, gradually renounced a photographic style of analysis for their rural subjects. Not only Clausen and La Thangue but also Stott and Hall had begun to move closer to Impressionism, placing greater emphasis on the study of the varying effects of light. In Scotland, the artists associated with the Glasgow Boys group of the 1880s had, by the turn of the century, evolved in many different ways. Artists such as E.A. Hornel and his associate George Henry abandoned naturalism for a more decorative, Symbolist style.[4]

In the first decade of the twentieth century La Thangue's work in particular regularly displayed technical associations with Impressionism, and this was noted by critics, the *Graphic* commenting, "Mr La Thangue shows by the lack of expression in his figure's faces that he sympathizes more with nature and the effects of atmosphere and light than with the men and women whose hard lives he paints".[5] Like Bastien-Lepage a quarter of a century earlier, La Thangue now borrowed certain aspects of Impressionism that suited his needs and interests. Broken paintwork, using a heavily loaded brush, became, by 1900, the characteristic treatment of all his canvases. He adopted a palette of warm-coloured pigments in order to convey the feeling of hazy summers in tranquil rural settings, though without really experimenting with Impressionism's interest in a pure, colouristic application of paint.

As a result of their experiments with varied sunlight effects, La Thangue, along with Clausen and Edward Stott, were felt to be standard-bearers of a generally more atmospheric rustic vision, as opposed to the photo-realist works with which they had dominated exhibitions previously. These new paintings were generally preferred by critics, with the *Graphic* commenting of their work at the Royal Academy as early as 1899:

"The felicitous blending of figure and landscape by Mr Clausen, Mr La Thangue and Mr Edward Stott is one of the features of the exhibition, although the public may not so appreciate it … these are the leaders of a school which … lends to the Academy an invaluable touch of rustic freshness and sincerity."[6]

Ultimately it was to be Clausen's work that was picked out by critics as most convincingly conveying the principles of Impressionism and it was to be Monet rather than Bastien-Lepage with whom he was compared.

By the beginning of the twentieth century, Edward Stott, too, had established a similar style, with which he would persevere until his death in 1918. The *Art Journal* of 1899 described Stott as a "poet-painter", who, "For ten years … has made Amberley his Barbizon, and the Sussex peasant and the Sussex fields are revealed in poems of colour and light".[7] Stott specialized in romantic images of rural England, with twilight scenes of life in and around Amberley. *Approaching Night* (cat 23), painted not long before his death, is typical of his dreamy rusticity.

Henry La Thangue's vision of rural life remained consistently romantic throughout the first three decades of the twentieth century, until his death in 1929. Whilst his later work became formulaic, support of his methods unexpectedly came from Walter Sickert in 1914, when he praised La Thangue's work on exhibition at the Leicester Galleries. Sickert, too, compared La Thangue's work with that of Monet, but acknowledged that he was not slavishly imitating Monet as had "a horde of followers without much personal vision of their own".[8]

Late works by La Thangue such as *The Appian Way* (cat 18) and *Packing Stocks* (cat 17), both from the 1920s, illustrate the artist's commitment to an Impressionistic palette and technique during his final years. A problem for contemporaries in assessing the mature work of artists like La Thangue and Stott, however, was illustrated as early as 1906 when one critic commented that both artists "merely repeat what they have said before".[9]

The early twentieth century also saw a younger generation of artists emerge who painted Impressionistic images of rural life. Alfred Munnings, who described La Thangue as "one of my gods" during the early years of the twentieth century, painted *Whitsuntide, a Gala Day* (cat 8) in 1902, an image that owes much to the rustic images of Clausen, La Thangue and Stott.[10]

Fred Hall was a contemporary of the latter three artists, and was resident at the Newlyn colony (see next chapter) between 1883 and 1898. He began experimenting with Impressionism during the late 1890s and into the twentieth century, producing a series of nostalgic images of rural life. Hall's *Preparing for Sheep-washing* (cat 25) is comparable with Harry Fidler's *Work* (cat 16) of the late 1920s. Fidler, like Hall, used a heavily textured paint technique to produce images of everyday scenes on a working farm. It is perhaps not surprising that these timeless images of rural life should be produced at a time when the nation was desperate for reassurance after the horrors of the First World War.

Philip Connard was an artist who not only lived through the Great War but actually served on the Somme, where he was attached as a war artist to the Admiralty. *A Chelsea Interior* (cat 15), painted shortly before the outbreak of war, has echoes of the Edwardian Impressionism associated with Sickert's circle of devotees within the New English Art Club, particularly artists like William Orpen and Henry Tonks. Connard was a member of the New English Art Club, although he was described by one writer as showing "little of the influences prevailing in the world of art".[11]

Of all the artists discussed here, the one with the greatest credentials with regards to French Impressionism was Lucien Pissarro, son of the great Camille. Taught by his father and also by Manet and Cézanne, he exhibited at the Impressionist exhibition of 1886 and with Seurat in the Salon des Indépendants the same year. He settled in England in 1890, becoming an associate of Sickert and Charles Shannon, and exhibited at the New English Art Club. Pissarro died in 1944 in the village of Hewood on the Dorset-Somerset border, where he had painted *A Muddy Lane, Hewood* (cat 22) four years earlier.

It is important to appreciate that when works by the naturalist generation of Bastien-Lepage were purchased by North West museums in the twentieth century artists like La Thangue, Stott, Clausen and others were already at the later stages of their artistic careers. It appears very much that these generally conservative images of rural life, fused with elements of Impressionist technique, appealed to the tastes of those selecting works for the municipal collections in the North West. In a sense it is ironic that the industrial base from which the wealth of these northern towns and cities derived had effectively destroyed much of the reality behind the images of rustic life they sought to purchase for the walls of their galleries.

1. The exhibition at the Grafton Galleries organized by Durand-Ruel included works by Boudin, Cézanne, Degas, Monet, Manet, Morisot, Camille Pissarro, Renoir and Sisley.
2. André Theuriet, *Jules Bastien-Lepage and His Art. A Memoir*, London (T. Fisher Unwin) 1892, pp. 111–27.
3. For a fuller discussion on naturalist artists' use of photography see Gabriel Weisberg, *Beyond Impressionism: The Naturalist Impulse in European Art 1860–1905*, London (Thames & Hudson) 1992.
4. For a full account of the Glasgow Boys see Roger Billcliffe, *The Glasgow Boys, The Glasgow School of Painting, 1875-1895*, London (John Murray) 1985.
5. Anon., 'The Royal Academy II', *Graphic*, 6 May 1899, p. 578.
6. *Ibid.*
7. A.C.R. Carter, 'The Royal Academy of 1899', *Art Journal*, 1899, p. 164.
8. Cited from Osbert Sitwell (ed.), *A Free House! Being the Writings of Walter Richard Sickert*, London 1947, p. 271.
9. Anon., 'The Royal Academy II', *Academy*, 12 May 1906, p. 455.
10. Sir Alfred Munnings, *An Artist's Life*, London (Museum Press) 1950, p. 138.
11. Anon., obituary, *The Manchester Guardian*.

15

Philip Connard
(1875–1958)
A Chelsea Interior, c. 1914
Oil on canvas
100.5 x 75 cm

Born in Southport, Connard was a largely self-taught artist, who was
drawn to a bright palette for both the landscape and the interior scenes
he painted. He exhibited with the New English Art Club and at the Royal
Academy, where he went on to become Keeper of the Royal Academy
Schools.

16

Harry Fidler
(1856–1935)

Work, c. 1928
Oil on canvas
136 x 183 cm

The son of a farmer, Harry Fidler was born in
Teffont Magna in Wiltshire. His youth spent on a
farm influenced his choice of subject-matter as
he developed his artistic career, and he
concentrated chiefly on rural genre scenes. He
studied at Hubert Herkomer's school at Bushey,
and went on to exhibit with the New English Art
Club and at the Paris Salon. Most of his working
life was spent near Andover in Hampshire.

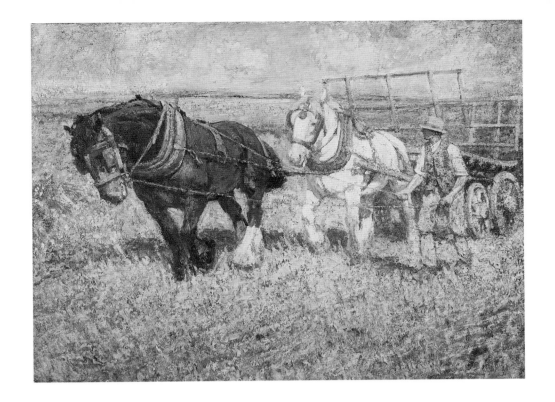

17

Henry Herbert La Thangue
(1859–1929)

Packing Stocks, c. 1920
Oil on canvas
66 x 76 cm

Born in Croydon, La Thangue studied at the Royal
Academy Schools before training at the atelier of Jean-
Léon Gérôme in Paris. During summers spent on the
Brittany coast he began to produce works inspired by
the rural naturalism of Jules Bastien-Lepage. On his
return to Britain he became a leading proponent of this
style throughout the 1880s, before moving towards a
more Impressionistic palette. From 1900 La Thangue
began to spend more time each year in the South of
France, Spain and Italy. These locations provided simple
rural subjects such as *Packing Stocks* and *The Appian
Way,* subjects of a kind that La Thangue felt had all but
disappeared in England.

18

Henry Herbert La Thangue
(1859–1929)

The Appian Way, c.1920
Oil on canvas
74.5 x 84.5 cm

19

George Clausen
(1852–1944)

The Golden Barn, c.1910
Oil on canvas
68.5 x 56 cm

After studying in Paris Clausen became the leading follower of Jules
Bastien-Lepage's naturalist style, specializing in single-figure
compositions. From the 1890s he was drawn to a more Impressionistic
technique and was particularly inspired by Monet in his palette and
choice of subject-matter. He spent much of his working life based in the
Essex countryside, which provided the material for many of his paintings.

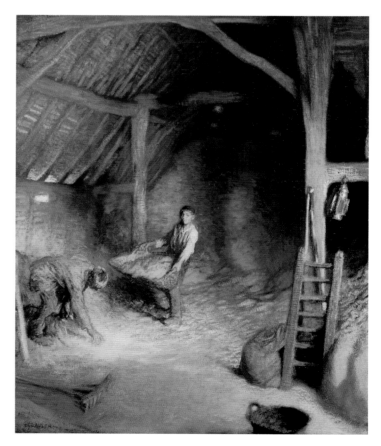

20

Edward Atkinson Hornel
(1864–1933)

Among the Lilies, 1905
Oil on canvas
100 x 76.2 cm

Trained in Edinburgh and then in Antwerp at Verlat's Academy, Hornel
was initially a follower of Bastien-Lepage. He quickly moved towards a
more decorative style when he began to collaborate with fellow 'Glasgow
Boy' George Henry during the 1890s. They visited Japan together in
1893–94, a trip which was to have a profound effect on his art,
encouraging him to place new emphasis on colour and pattern. The
decorative surface patterns of *Among the Lilies* create a startling effect.

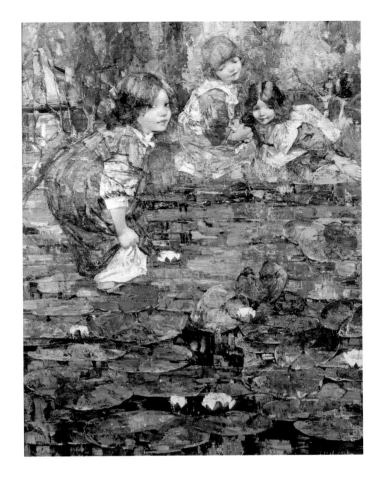

21

John Lavery
(1856–1941)

Schooling the Pony, 1929
Oil on canvas
77 x 103 cm

Born in Belfast, John Lavery became one of the Glagow
Boys after studying in Paris and spending time at the
nearby artists' colony of Grez-sur-Loing in the Forest of
Fontainebleau. His early work was strongly influenced by
Bastien-Lepage, but after returning to Glasgow he
concentrated on more commercially successful subjects
of the wealthy at play, such as *The Tennis Party*
(Aberdeen Art Gallery). After painting Queen Victoria in
1888 he became established as one of the most
fashionable society portraitists of the day. During the
1920s he painted a series of pictures associated with
horses and racing.

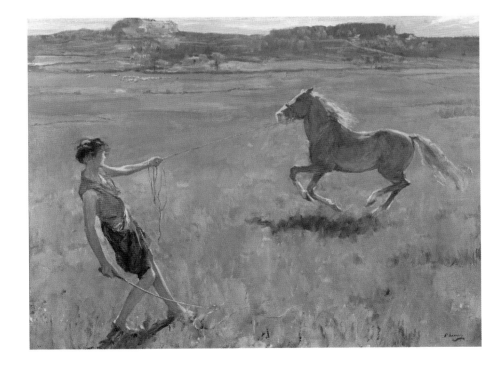

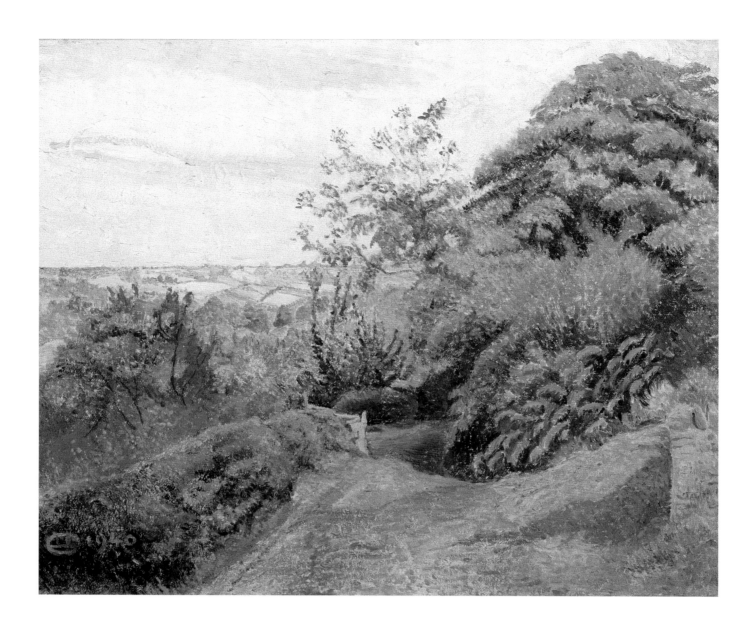

22

Lucien Pissarro
(1863–1944)

A Muddy Lane, Hewood, 1940
Oil on canvas
46 x 56 cm

Lucien was the eldest son and pupil of the leading French Impressionist Camille Pissarro. In 1890 he settled in London, where he continued to work in the Impressionist style. Befriended by Walter Sickert, he joined the Fitzroy Street Group of artists before going on to become a founder member of the Camden Town Group. He spent the last part of his life in Hewood in Dorset, with many of his landscapes inspired by the surrounding countryside.

23

Edward Stott
(1855–1918)

Approaching Night, c.1917
Oil on canvas
55.8 x 77.1 cm

Born in Rochdale, Stott studied at the Manchester
Academy of Fine Arts and in Paris under Carolus-Duran
and Cabanel. His rural naturalism was particularly noted
for its atmospheric effects. He spent much of his
working life at Amberley in Sussex, where the
surrounding countryside provided the inspiration for his
paintings. Whilst initially inspired by Bastien-Lepage,
Stott was more often compared, for the timeless qualities
of his landscapes, to Millet.

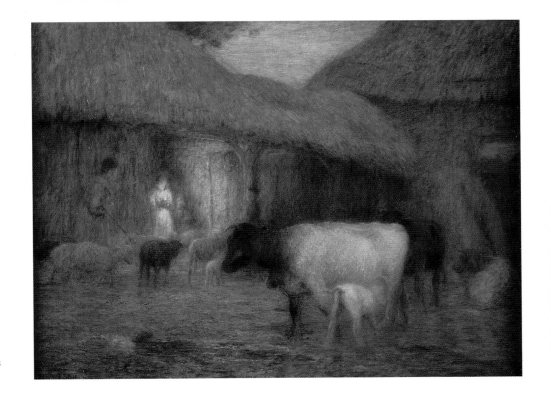

24

Walter Frederick Osborne
(1859–1903)

Summertime, 1901
Oil on canvas
106.5 x 122 cm

Dublin-born, Osborne studied in Antwerp and followed
the *plein-air* naturalist tradition. At the time of his early
death – forty-four years old – he was regarded as a
leading Impressionist artist, noted for his atmospheric
landscapes influenced by the time he spent in France in
the last quarter of the nineteenth century.

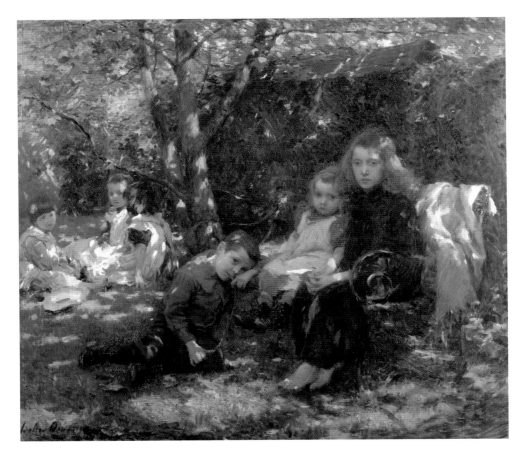

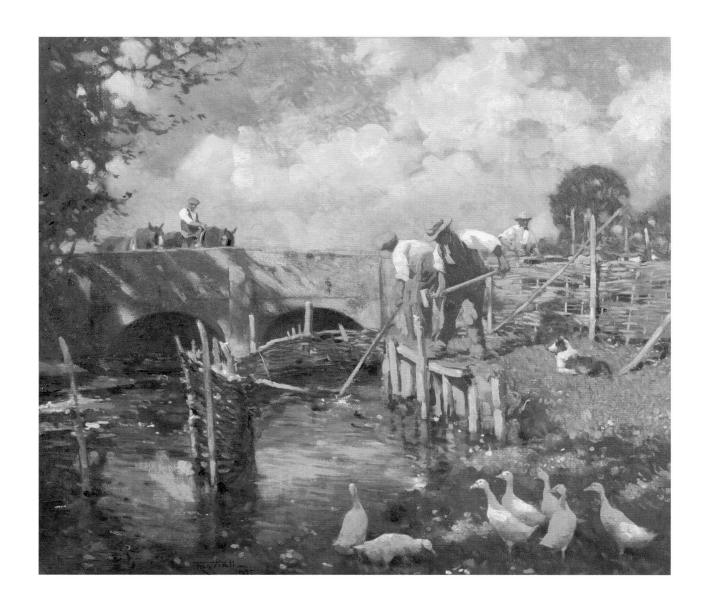

25

Frederick Hall
(1860–1948)

Preparing for Sheep-washing
Oil on canvas
66 x 74.8 cm

Born in Stillington, Yorkshire, Fred Hall studied with Walter Osborne at Verlat's Academy in Antwerp.
On returning to England he settled in 1885 in Newlyn, where he continued to pursue *plein-air*
naturalism. From the 1890s he began experimenting with Impressionist techniques. In 1911 Hall
moved near Newbury, where he lived for the rest of his life, depicting the local Berkshire countryside.
His work is characterized by its essentially English nature – rolling landscape filled with animals
feeding and fieldworkers. *Preparing for Sheep-washing* was exhibited at the Royal Academy in 1935.

Artists' Colonies

Birch

Forbes

Harvey

Langley

Olsson

Procter

Sharp

L. Knight

Park

H. Knight

Tuke

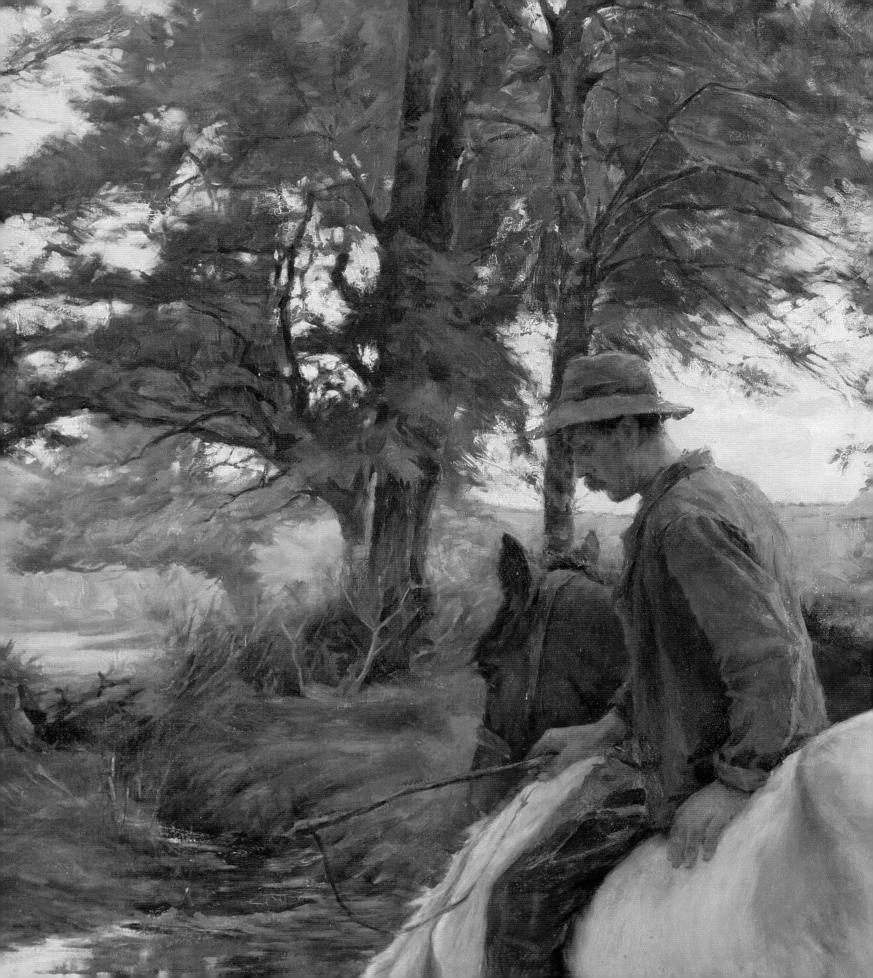

Artists' Colonies

by Adrian Jenkins

"A very nest of bohemians" was the phrase the American artist John Singer Sargent used in 1875 to describe the blossoming artists' colony of Grez-sur-Loing, near Barbizon in the Forest of Fontainebleau, a relatively short train journey from Paris.[1] It was an apt description. Colonies of artists had developed in France in places like Barbizon, Grez and around the Brittany coast from the mid nineteenth century.[2] They offered artists from all over Europe and America studying in Paris an opportunity to observe and paint a rapidly disappearing traditional rural life at first hand. It was to these kinds of locations that British students of the early 1880s, such as Stanhope Forbes, Henry La Thangue and George Clausen, studying in Paris, would travel to spend their summer vacations painting. Drawn to the Bohemian lifestyle and subject-matter colony life offered, many British artists sought out similar remote locations on concluding their training and returning home.[3]

The development of artists' colonies in Britain was modelled on those in France. They were generally found in towns and villages dependent on traditional economies such as agriculture and fishing, thus providing painters with subject-matter in which to explore the relationship between man and nature. Artists such as Walter Osborne and Philip Wilson Steer were drawn to the picturesque village of Walberswick in Sussex, whilst the North Yorkshire fishing village of Staithes was also favoured by many artists. In Scotland, some of the artists associated with the group known as the Glasgow Boys worked around the villages of Brig O'Turk and Cockburnspath.

It was the Cornish peninsula, however, that became by far the most popular location for artists.[4] The resemblance between Cornwall and Brittany was almost certainly part of the attraction, for they shared similar traditions and landscape. The town of Newlyn was the first of these colonies to come to prominence. It was a thriving fishing village, the older part of which consisted of picturesque steep cobbled streets. A number of artists had begun to come to Newlyn from the beginning of the 1880s. Most of them had trained in Paris or Antwerp and shared common artistic ideals inspired by the form of rural naturalism championed by the French painter Jules Bastien-Lepage.[5]

During his training in France, spending summers along the Brittany coast at Cancale and Concarneau, Stanhope Forbes had become an exponent of Bastien-Lepage's methods. Attracted to the camaraderie of colony life in France he was drawn to Cornwall on returning home. He settled in Newlyn early in 1884 and quickly became the acknowledged leader of the colony. It was Forbes who was really responsible for putting Newlyn on the artistic map. His Royal Academy submissions achieved widespread acclaim and recognition, most notably *A Fish Sale on a Cornish Beach* (1885, Plymouth City Museum and Art Gallery). Forbes spent the rest of his career in Newlyn, finding ready subjects in the local people, like the farmer who appears in *The Drinking-place* (cat 27), and their surrounding landscape.

The Birmingham-born painter Walter Langley had been among the first artists to settle in Newlyn. He had holidayed there in 1880, before settling permanently with his family in 1882. Working almost exclusively in watercolour, often on a large scale, Langley never enjoyed the wider acclaim that painting in oil would have brought him, although he was extremely successful commercially. As Forbes commented, "He sells all he does as fast as done".[6] His work was highly accomplished, capturing the faces of his subjects with astonishing clarity. Langley's work contained a strong sense of narrative. He was particularly drawn to melancholic subject-matter, inspired by the harsh and often precarious nature of fishing life he saw around him in Newlyn. The tragic young woman left widowed by the death of her husband at sea, as depicted in *The Tender Grace of a Day that is Dead that will never come back to me* (cat 29), was a theme he dwelt on repeatedly.

Henry Scott Tuke preferred to paint the male nude on a sunlit beach rather than the plight of fisher folk. He visited Newlyn in 1883 and continued to return before settling at nearby Falmouth. Particularly noted for his use of bright colours, Tuke often used the names of colours in the titles of his pictures, as in *Grey and Green* (cat 36). Falmouth provided a better setting for this type of picture, having more secluded beaches and being a centre for sailing, which also often featured in his work.

As well as offering the artists an opportunity to share artistic ideals, colony life encouraged an active social scene. An amateur dramatic society was established at Newlyn, dinner parties were regularly thrown and an important fixture was the annual cricket match against artists from the nearby colony at St Ives.

In contrast to Newlyn, St Ives was a popular tourist resort and far more commercially developed than Newlyn. Its reputation as an artistic centre began to emerge in the later 1880s. Whistler and Sickert were amongst the first artists who worked there, in early 1884. With its charming beaches and beautiful coastline St Ives was more popular with landscape painters while figure painting dominated in Newlyn, although Newlyn artists, including Forbes, regularly visited and worked in St Ives. The colony was particularly popular with American and Scandinavian artists, among them the Swedish painter Anders Zorn.

One of the most prominent English artists at St Ives was Julius Olsson, a landscape painter who settled in St Ives in 1890. Like the Newlyn artists, Olsson was committed to painting outdoors, concentrating his efforts on observing the changing nature of the sea along the Cornish coast. Moonlit scenes, as in *Rising Moon, St Ives Bay* (cat 30), were a particularly favoured effect. In 1895 he established a School of Landscape and Marine Painting in St Ives. One of its most talented students was John Park, who studied there between 1902 and 1904 and became well known for his brightly coloured scenes of boats in St Ives harbour.

In 1899 Forbes and his wife Elizabeth (née Armstrong), herself a distinguished painter, opened a school of painting which was to be responsible for bringing a new generation of artists to Cornwall. The emphasis was on painting out-of-doors and the study of the human figure, with many local people acting as models for the students' drawing classes. The new generation of artists chose subject-matter that was more light-hearted and exuberant than the sometimes sombre studies of local life produced by the earlier one. They also generally used a more brightly coloured palette and tended to be influenced by the Impressionists rather than by Bastien-Lepage.

The Newlyn to which the new generation of artists came was quite different from the Newlyn which the first artists had encountered, as one of the original artists of the colony, Norman Garstin, noted:

"When Mr Stanhope Forbes painted his *Fish Sale* there was no harbour, today there is a spacious one, which ... is crowded with fishing boats, steamers, sailing vessels and craft of all description. All this has brought a life and animation that no one would have dreamt of a quarter of a century ago."[7]

An early pupil of Forbes's school was Dod Procter, who had enrolled at the tender age of fifteen. She went on to achieve great success with her distinctive paintings of monumental female figures, generally nude, in muted colours. *The Bather* (cat 31) is typical of Procter's work.

Another prominent member of the second generation was 'Lamorna' (Samuel J.) Birch, who came to Cornwall in the early 1890s. On Forbes's advice he went to Paris to study, but his predominant interest in landscape painting led him to settle in the Lamorna valley, near Newlyn. He set himself apart from the Newlyn artists, and Lamorna itself quickly became established as a colony in its own right. Birch developed a strong following for his large-scale, dramatic landscapes like *Serpentine Quarry, near Mullion* (cat 26), one of a number of similar works shown at the Royal Academy during the 1920s.

Amongst the other artists that joined Birch at Lamorna were Laura and Harold Knight. They had previously lived at the North Yorkshire fishing town and artist colony of Staithes, where Laura had painted *The Fishing Fleet* (cat 6) before their marriage. *The Fishing Fleet* is representative of the dark, muted, tonal palette both the Knights used in their paintings whilst in the Staithes colony. They moved from Staithes to Cornwall in 1906, first living in Newlyn before settling near Lamorna. With the outbreak of the First World War, Harold became a conscientious objector, a stance that led him to be shunned by his fellow artists and the locals alike. At the end of the war the Knights moved to London but retained studios at Sennen Cove in Cornwall, where they returned during the summers of the 1920s. Laura painted a number of landscapes around here as well as some interiors, the latter influenced by Dod Procter, a close friend. *Susie and the Washbasin* (cat 34) is a classic example of these. Whilst continuing the tradition of painting out-of-doors, Laura Knight often invited professional models from London rather than using the locals in her pictures.

Harold Harvey was one of the few Newlyn artists who was actually a native of Cornwall. Born in Penzance, he had studied under Norman Garstin. Having continued his training in Paris, Harvey returned to Newlyn at the turn of the century and there was drawn to rural scenes of farmworkers and of children playing. The outbreak of the First World War led him and the Knights to turn towards interior scenes, for it became increasingly difficult to obtain the permits which were required for paintings or drawing outdoors. In works like *My Kitchen* (cat 28), the influence of the seventeenth-century Dutch interiors of Vermeer and Pieter de Hooch is particularly apparent.

By the 1920s Cornwall was no longer at the forefront of British art. Artists continued to be attracted to the brilliant light and attractive coastline but much of the work produced there appeared conservative compared to the experiments of the Modernists. Obscurity was avoided, however, when the area became home to a new group of artists who were in the vanguard of these new developments. In 1928 Ben Nicholson and Christopher Wood visited St Ives and were drawn to the simplified paintings of an untrained local fisherman, Alfred Wallis. Nicholson settled at St Ives with his wife Barbara Hepworth at the outbreak of the Second World War, once again establishing the town as a centre for the avant-garde. During the 1950s and 1960s younger artists like Roger Hilton, Patrick Heron and Peter Lanyon followed, consolidating the town's reputation as a centre for abstraction and attracting visits from leading American Abstract Expressionists including Mark Rothko and the critic Clement Greenberg.

It is the very broad and lengthy appeal of Cornwall that distinguishes it from so many other artists' colonies, the popularity and reputation of which were generally confined to a short period before being superseded by more up-and-coming locations. That the area around Newlyn and St Ives was able to retain and secure its attraction for artists from the era of Victorian representation through to the developments of Modernism and Abstraction makes it a unique location. It is this broad history that has ensured its continuing reputation. The establishment of the Tate Gallery's outpost at St Ives has meant that it continues to be a home to both distinguished and emerging art today.

1. Letter to Vernon Lee, 16 August 1881 (private collection), cited from Elaine Kilmurray and Richard Ormond (eds.), *John Singer Sargent*, London (Tate Gallery Publications) 1998, p. 12.
2. Pont-Aven, Cancale and Concarneau were amongst the most popular colonies on the Brittany coast.
3. For a discussion of artist colonies see Michael Jacobs, *The Good and Simple Life. Artist Colonies in Europe and America*, Oxford (Phaidon) 1985.
4. For further discussion of the Newlyn and St Ives colonies see Caroline Fox and Francis Greenacre, *Painting in Newlyn 1880–1930*, exh. cat., Barbican Art Gallery, London, 1985, and Tom Cross, *The Shining Sands – Artists in Newlyn and St Ives 1880–1930*, Tiverton (Westcountry Books) 1994.
5. For more on Bastien-Lepage see the previous essay and André Theuriet, *Jules Bastien-Lepage and His Art. A Memoir*, London (T. Fisher Unwin) 1892.
6. Forbes, letter of 14 February 1884, cited in Adrian Jenkins, *Painters and Peasants. Henry La Thangue and British Rural Naturalism 1880–1905*, exh. cat., Bolton Museum and Art Gallery, 2000, p. 95.
7. Caroline Fox, *Stanhope Forbes and the Newlyn School*, Newton Abbot (David & Charles) 1993, p. 72.

26

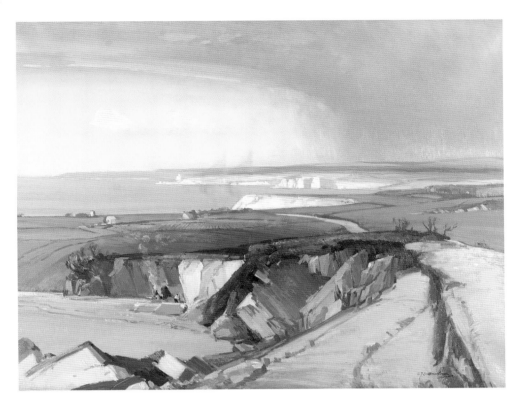

Samuel J. ('Lamorna') Birch
(1869–1955)

Serpentine Quarry, near Mullion, c. 1917
Oil on canvas
90 x 120.5 cm

Born in Egremont, Cheshire, Samuel Birch worked initially as
an industrial designer in a linoleum factory before securing
the financial freedom to turn to painting. He first visited
Newlyn in 1889 but his love of landscape drew him to the
nearby Lamorna valley, where he settled in 1892. Whilst
there he came under the influence of Stanhope Forbes, who
encouraged him to adopt the name of the valley in order to
distinguish himself from another Newlyn artist, Lionel Birch.
Serpentine Quarry, Mullion is typical of Birch's large-scale
landscapes depicting the area around Lamorna.

27

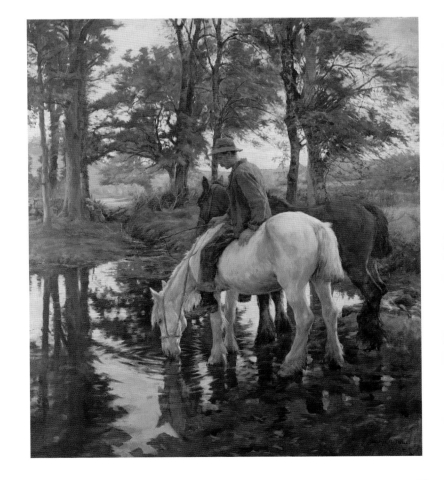

Stanhope Alexander Forbes
(1857–1947)

The Drinking-place, 1900
Oil on canvas
152.5 x 174 cm

Forbes was born in London and attended Dulwich College in London
with Henry La Thangue. They both went on to study at the Royal
Academy before travelling to France and painting together during
summers on the Brittany coast. Forbes came to Newlyn in 1884 and was
responsible for bringing the colony of artists to the attention of the
London public and critics. By the turn of the century most of the original
Newlyn artists had left, but Forbes remained, continuing to paint scenes
of local life. *The Drinking-place* depicts a local farmer, John Phillips, on
horseback and is probably set in the Lamorna valley.

28

Harold Harvey
(1874–1941)

My Kitchen, 1923
Oil on canvas
100.5 x 77.5 cm

Born in Penzance, Harvey trained initially under the Newlyn artist Norman Garstin and then at the Académie Julian in Paris. He returned to Newlyn as one of the second generation of artists working there and would remain in Newlyn for much of his life. Initially painting *plein-air* subjects imbued with Impressionist colour and light, Harvey turned to interior scenes as the outbreak of the First World War placed restrictions on painting out-of-doors. *My Kitchen* reflects Harvey's appreciation of seventeenth-century Dutch interior painting. Harvey's wife, Gertrude, is thought to have been the model for the figure in the white dress.

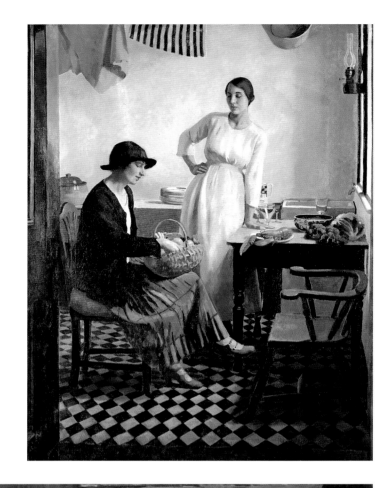

29

Walter Langley
(1852–1922)

The Tender Grace of a Day that is Dead that will never come back to me, 1909
Oil on canvas
115 x 105.5 cm

Unlike the majority of Newlyn artists, Langley came from a working-class background in Birmingham. He was one of the first artists to settle in Newlyn, but as he worked mainly in watercolour did not achieve the same recognition as others there. The title of this painting is taken from a line in Tennyson's poem *Break, break, break* and is typical of the melancholy narrative strain in Langley's work.

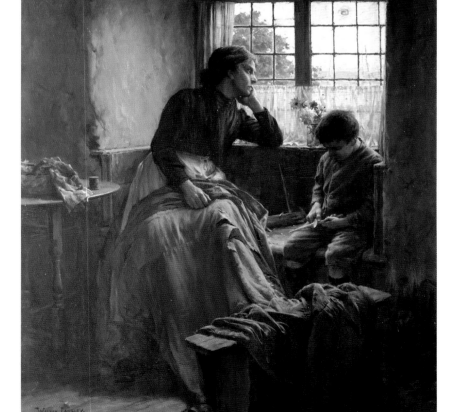

30

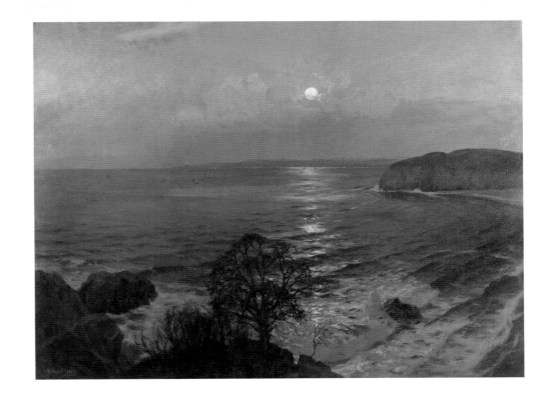

Julius Olsson
(1864–1942)

Rising Moon, St Ives Bay, c. 1905
Oil on canvas
115.5 x 151 cm

Born in London to a Swedish father and English mother, Olsson initially worked in a City bank. Without any formal training, he was drawn principally to landscape and marine subjects. He first arrived in St Ives in 1890, establishing his School of Landscape and Marine Painting there in 1895. Like the Newlyn artists, Olsson was committed to painting out-of-doors and to direct observation from nature. His principal concern was to capture the movement of the sea and the effect of changing light on the colours in the water. When it was exhibited in 1938, the *St Ives Times* described *Rising Moon, St Ives Bay* as "a picture of emotional reaction to the view from Penolver to Godrevy, lit by an early moonrise".

31

Dod Procter
(1892–1972)

The Bather, c. 1930
Oil on panel
67.2 x 41 cm

Dod Procter came to Newlyn in 1906 and began to study at the Forbes's school at the age of fifteen. It was there that she met her future husband, Ernest. They remained in Newlyn for the rest of their lives. Whilst studying in Paris, Dod was drawn to the work of Seurat, Cézanne and Renoir. She developed a distinctive style, concentrating on monumental depictions of nude female figures, of which *The Bather* is typical.

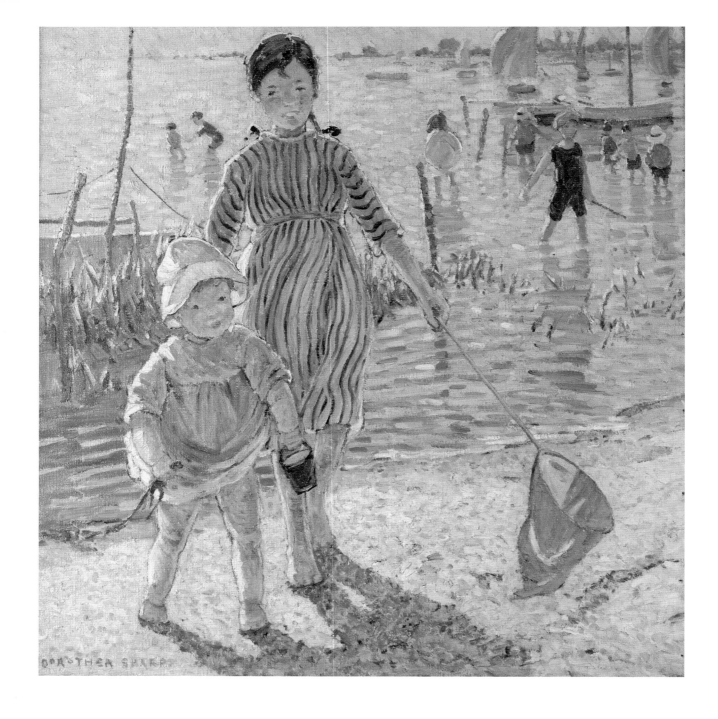

Dorothea Sharp
(1874–1955)
Paddlers, c. 1936
Oil on canvas
87 x 84 cm

Born in Dartford, Kent, Dorothea Sharp trained under Sir George Clausen before studying in Paris. It was here that she encountered the work of Monet, which was profoundly to influence the development of her style. Her principal subjects were brightly coloured pictures of children bathed in sunlight, often on the beach at St Ives. Described by *The Artist* as "one of England's greatest living woman painters", she exhibited at the Royal Academy throughout her career.

33

Harold Knight
(1874–1961)

Reading the Letter, 1906
Oil on canvas
101.5 x 127 cm

Harold Knight studied in his home town of Nottingham
before enrolling at the Académie Julian in Paris. Having
employed a dark palette whilst in Staithes, he
considerably lightened the tones of his paintings after his
move to Newlyn in 1906. Knight was principally a painter
of interiors, depicting figures in carefully lit scenes.

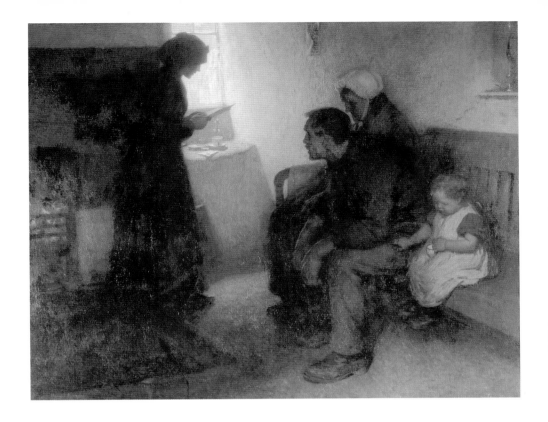

34

Laura Knight
(1877–1970)

Susie and the Washbasin, 1929
Oil on canvas
61 x 61 cm

In 1907 the Knights moved to Newlyn, and continued to
return there regularly after moving to London at the
outbreak of the First World War. Whilst in Newlyn Laura
Knight developed a close friendship with Dod Procter,
who influenced the style of her interior scenes like *Susie
and the Washbasin*. Laura Knight was created a Dame of
the British Empire in 1929.

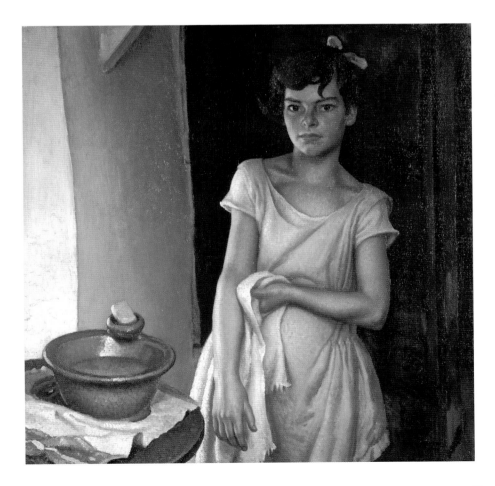

35

John Park
(1878–1962)

Morning Tide, 1924
Oil on canvas
66 x 91.5 cm

Born into a family of painter decorators in Preston, Park began to paint full time in 1897. He studied at Julius Olsson's school in St Ives between 1902 and 1904 and then in Paris. He returned to St Ives in 1906, settling there more permanently in 1923. Inspired by the Impressionists, he produced brilliantly coloured views of the coast and harbours around St Ives. These works were produced on a large scale for exhibitions and at more modest size to meet the demands of the tourist market.

36

Henry Scott Tuke
(1859–1929)

Grey and Green, c. 1906
Oil on canvas
56 x 39cm

Born in York, Tuke first studied at the Slade School of Art before going on to train in Paris. Whilst a frequent visitor to Newlyn he was actually based in the nearby sailing port of Falmouth. Tuke attracted a certain notoriety for his paintings of nude boys bathing, which was to be his main subject-matter throughout his career.

Mainstream Modernists

Allinson

Bayes

Fitton

Gosse

Lowry

McBey

Orpen

Rothenstein

Workman

John

Lessore

Sickert

Spencer

Cadell

Lamb

Ginner

Carline

Mainstream Modernists

by Dinah Winch

When Augustus John was elected an Associate of the Royal Academy in 1921 he answered those who criticized his move into the establishment by setting out his radical credentials: "Had I not been a Slade student? Was I not a member of the New English Art Club?"[1] In the last two decades of the nineteenth century artists had begun to look for alternatives to the Royal Academy and in 1871 the Slade School was founded, followed in 1886 by the formation of the New English Art Club by artists who wanted an alternative exhibiting forum. By the 1920s a more plural mainstream had evolved that could accommodate not only the Royal Academy and the supposedly radical alternative, the New English Art Club, but the fluid movement of individuals between these two and more avant-garde groupings.

Many of the artists working in this alternative world in the early twentieth century could be more accurately defined by their opposition to academicism than by their adherence to a particular movement or creed. They include four of the great independent spirits of British art, Augustus John, Walter Sickert, L.S. Lowry and Stanley Spencer. Of the artists who were part of the new modern movement; most had studied at the Slade and exhibited at the New English Art Club, while some were part of groups such as the Camden Town Group and the London Group. But for all their progressive instincts these artists never departed from representation, even though many experimented with various forms of heightened and distorted realism and symbolism.

The New English Art Club was set up to provide a venue for those artists who wanted to exhibit their French-influenced paintings, which were not accepted by the Royal Academy. Founder members included Stanhope Forbes and H.H. La Thangue, and the Club's early exhibitions were dominated by English Impressionists. The New English Art Club's exhibitions were a natural outlet for ex-students of the Slade School, founded as an alternative to the Royal Academy and South Kensington art schools. Slade School teaching emphasized the overall composition rather than the effect of detail and was, on the whole, characterized by a lack of concern with social realism. The Slade's first professor, Edward Poynter, believed that "constant study from the life-model is the only means we have of arriving at a comprehension of the beauty of nature".[2] Students were taught that form should be naturalistic, though not photographic, and an eclectic approach to the study of the Old Masters was encouraged. Augustus John's draughtsmanship was favourably compared with that of Rubens and William Orpen's compositions with those of Watteau, Goya and Fragonard. In *A Corner of the Talmud School* (cat 44), William Rothenstein adopts the colouring and tonality of Rembrandt, like many Slade School artists in this period.

John and Orpen were important figures in establishing the Slade's anti-establishment credentials. In their choice of subject-matter, dress and lifestyle, they cultivated a dandified bohemianism that was hugely influential on their peers. Both were seduced by a romantic view of Romany life and mixed in Gypsy circles. Orpen met George and Edith, the Hungarian couple in *In the Dublin Mountains* (cat 43) in 1909 and was captivated by them, and by their bear, drawing numerous sketches of them, as well as painting two large canvases. The romantic subject-matter, fine description of texture and Manet-like placement of the figures in this painting typify the guarded modernism of the earlier phase of Slade School painting.

In 1905 Vanessa Bell could still describe the New English Art Club as the "most go-ahead group in modern art",[3] but the organization was starting to be perceived as reactionary. Young artists who later became central figures in the modernist avant-garde, such as Mark Gertler, exhibited there for lack of a viable alternative but were already looking for new outlets for their work. By 1910 some of the key members of the New English Art Club were restless. Sickert criticized the formulaic nature of the work that was exhibited there: "The NEAC picture has tended to be a composite product in which an educated colour vision has been applied to themes already long approved and accepted".[4]

In his Second Post-Impressionist exhibition at the Grafton Galleries in 1912 Roger Fry included the young British artists Duncan Grant, Vanessa Bell, Spencer Gore, Henry Lamb, Stanley Spencer and Charles Ginner. Fry was looking for artists whose work demonstrated a clear link to the three key figures of the First Post-Impressionism exhibition, Cézanne, Van Gogh and Gauguin. The impact of Post-Impressionism in Britain did not represent a sudden break with the past or widespread conversion to working in a new manner, but it did lead to an acceleration of developments that were already taking place.

One of the key emerging trends was an anti-naturalistic tendency, compared to the romantic realism of academic painting. Stanley Spencer's idiosyncratic perspective and mannered figures demonstrate an awareness of Cézanne's simplified forms and Gauguin's expressive figure-style, which stayed with him throughout his artistic career. Spencer would, however, constantly return to observed experience to ground his work in the material world. The influence of Gauguin is equally strong in Henry Lamb's *Breton Youth* (cat 52), though mediated by his contact with Augustus John, who, incidentally, declined Fry's offer to exhibit as a Post-Impressionist.

Several British artists were clearly influenced by the more advanced trends of French art well before 1912. Walter Sickert lived in Dieppe from 1898 to 1904. His painting of *The Fair, Dieppe* (cat 49), with its heavy outlines and flat areas of unmodified colour, has all the vibrancy of Van Gogh's night scenes and shares Whistler's fascination with the urban scene. Among the younger generation, Charles Ginner and Francis C.B. Cadell had both spent formative years in France. Cadell had not been chosen to exhibit in the Second Post-Impressionist exhibition, partly as a result of the marginalization of Scottish art in English art cirlces, but he was working in a recognisably Post-Impressionist style. Like many of his peers, he had initially been strongly influenced by Whistler but, along with his fellow 'Scottish Colourists' (J.D. Fergusson, S.J. Peploe, G. Leslie Hunter), he was increasingly interested in the work of the Fauves. The Scottish Colourists were not so much an organized network as a group of artists who were identified by their Scottishness and their love of colour and vigorous application of paint.

Sickert noted in 1910 that a new style was emerging of "a clean and solid mosaic of thick paint in a light key."[5] Charles Ginner epitomized the new generation of artists who were exploring new painting techniques and creating form through the structure of the application of paint. For Ginner realism was the artist's "personal expression of nature". He was hostile to the naturalism of the artist who "with infinite care … copies the superficial aspects of the object before him. He sees only nature with a dull and common eye, and has nothing to reveal …. Art then ceases, the decorative interpretation and intimate research of Nature, i.e. Life are no more." Like Sickert he believed that realism was about extracting from life "the very essence of all it contains of great or weak, of beautiful or of sordid, according to the individual temperament".[6]

The Post-Impressionist exhibitions divided the British art world and the critical reaction of the New English Art Club undermined any illusion that it was a radical organization. However, the idea of Post-Impressionism itself, as a cutting edge alternative to the *status quo*, soon came under attack from within. In his essay on Neo-Realism Ginner criticized it extensively, describing it as "a false cloak" which merely disguised an "Academic skeleton"

and deploring the decorative tendencies of many Post-Impressionist artists.[7] In 1911 Sickert, Ginner, John and Lamb established the Camden Town Group, exhibiting at the Carfax Gallery in 1911–12. Sickert taught them to bring together the lessons of Gauguin, Van Gogh and Cézanne while staying true to the principle of creating art born out of lived experience. Sickert wanted to explore the question how an artist could represent the experience of modern life. *Two Women* (cat 56) is a fairly typical picture of this period, with a very topical whiff of scandal. It is an image of working women, probably Alice and her grandmother Sarah Cook, who were porters at Covent Garden market; it was rumoured that Alice was the mistress of Queen Victoria's grandson. The subdued colouring and unselfconscious pose give the image a quality of reportage. Sickert would take this development further in later paintings, culled directly from newspaper cuttings.

Although Sickert never ceased to push at the boundaries of representational art, his followers in due course entered the mainstream of British art. The paintings of Sylvia Gosse and Therese Lessore and the later works of Charles Ginner became much less austere in composition and in colour, moving closer to a more broadly acceptable level of naturalism. Writing about the Camden Town Group in 1921, Frank Rutter remarked that "since 1918 there has been a general return to realism, but the experience of the extremists are [*sic*] not valueless. They have widened the horizon of painting and opened the road to the new realism in which the firm structure and rigid design of the Cubists will be combined with a truth and beauty of colour derived from the expressionists."[8]

Lowry was one of the most original of the representational artists to emerge during the first half of the twentieth century in Britain. Although he liked to give the impression of an untutored natural talent he was more connected to developments in the art world than is sometimes assumed and took from avant-garde practice what suited his personal vision. In 1942 he had become a member of the Artists International Association, probably introduced to the group through Oldham-born artist James Fitton in the late 1930s. By this stage the organization was less political than it had once been and was becoming simply a progressive exhibition society, showing artists such as Lowry and Fitton, whose subject-matter dealt with the social experience of urban and working-class life. Fitton's *Tavern Brawl* (cat 39), bought by Oldham Art Gallery in 1933, combines this tradition of social realism with Post-Impressionist trademarks of distorted perspective and strong planes of colour. Fitton worked at various times during his career as a commercial graphic artist and *Tavern Brawl* includes the strong pinks and greens of a contemporary lithographer's palette.

These artists moved between a series of various groupings and exhibiting societies that were a feature of this particularly fertile period of British art practice. They are difficult to classify and cannot be contained by neat categories and pigeonholes. Modern ideas about form, perspective, style and subject-matter were adopted, but contained and adapted by a new mainstream of painters who never abandoned representation.

1. Michael Holroyd, *Augustus John*, 2 vols., London 1975, II, pp. 105–06.
2. Simon Watney, *English Post-Impressionism*, London 1980, p. 10.
3. *Ibid.*, p. 9.
4. *Ibid.*, p. 25.
5. Charles Harrison, *English Art and Modernism*, New Haven and London 1981, p.35.
6. Watney 1980 (see note 2), p. 119.
7. Charles Ginner, 'Neo-Realism', *New Age*, January 1914. This essay was also reprinted in the catalogue of an exhibition of the work of Ginner and Gilman later that year.
8. David Peters Corbett, *The Modernity of English Art 1914–30*, Manchester and New York 1997, p. 72.

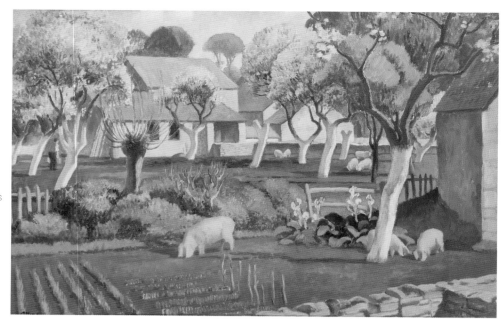

Adrian Allinson
(1890–1959)

Somerset Farm, c. 1935
Oil on canvas
55.8 x 78.7 cm

Allinson is best known as a theatrical scene-painter and caricaturist. He won a Slade School scholarship, along with his contemporary Stanley Spencer, and his earliest influence was Sickert. He illustrated a theatrical column in *The Daily Express* and became chief scenery designer to the Beecham Opera Company. This painting probably dates from the 1930s when he moved to Gloucestershire and developed his style of landscape painting. His creation of form in this painting is reminiscent of Spencer, though the strength of colour and design in the composition probably owes much to his experience as a scene-painter.

Walter Bayes
(1869–1956)

A Boire (Thirst), c. 1920
Oil on canvas
134.5 x 182 cm

Bayes was a member of the Camden Town Group. This painting was bought by Oldham Art Gallery in 1920. In a letter to the curator W.H. Berry, Bayes explained that the subject was "thirst in the South. It was suggested by a road running on the other side of the Rhone at Avignon, a road of dazzling whiteness which at certain times of the summer deluges with white dust everything which borders it ... till as in the lady stretching across my picture for her drink even the hair is powdered to pale grey."

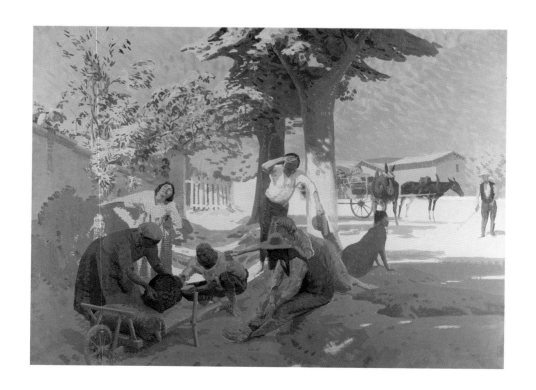

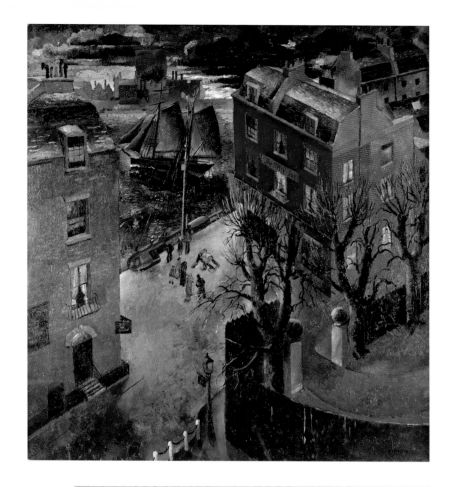

39

James Fitton
(1899–1982)

Tavern Brawl, c. 1932
Oil on canvas
79.3 x 87.5 cm

Fitton was trained at Manchester School of Art and later worked as a
commercial artist in London. He exhibited at the Royal Academy
Summer Exhibition from 1929 and was a member of the New English Art
Club, a member of the London Group and, in 1933, a founder member
of the Artists International Association. The location of this scene is
unidentified. The naïve style, with its irregular perspective and rather
detached presentation of the brawl, creates a sense of distorted realism.

40

Laura Sylvia Gosse
(1881–1968)

Dieppe, c. 1933
Oil on canvas
59.5 x 49.5 cm

Gosse taught and exhibited at the Royal Academy and became a
member of Sickert's circle. As a woman she was not allowed to join the
Camden Town Group, which Harold Gilman insisted was to remain male
only, but was a member of the London Group. Gosse never felt
comfortable in the British art world and settled permanently in Dieppe.

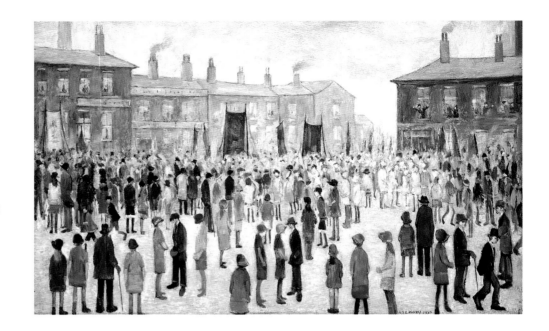

Laurence Stephen Lowry
(1887–1976)

The Procession, 1927
Oil on plywood
35.5 x 54.5 cm

The painting is based on a scene of Swinton Market and probably shows a Whit Walk, a theme that Lowry returned to in several paintings and drawings. He was concerned that his work often had a static quality, something that he has here clearly overcome with a looser handling of paint and composition. His use of colour is dynamic and the tones are clear, which gives *The Procession* a fresh quality not always associated with Lowry's work.

42

James McBey
(1883–1959)

Saada, 1936
Oil on canvas
79.2 x 63.5 cm

McBey is best known for his etchings, particularly from his time as an official war artist in the First World War. He had no formal artistic training. His oil paintings have a graphic quality which evolved from his experiments with painting in watercolour, applied in washes over drawings. When painting in oils he drew the outlines in black paint, filling them in with planes of lively but almost abstract colour. In 1912 he visited Morocco for the first time, returning frequently throughout the 1930s. Here he produced mostly watercolours and oil paintings of local scenes and people.

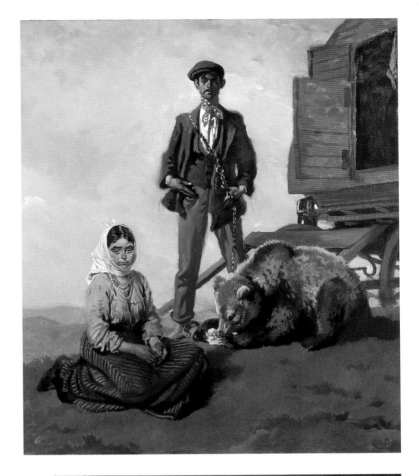

43

William Orpen
(1878–1931)

In the Dublin Mountains, 1909
Oil on canvas
117 x 99.3 cm

Orpen's early conventional success helped him steer clear of the various movements and alignments that characterized the British art world in the early twentieth century. This is one of two major canvases painted by Orpen of George and Edith, two Hungarian Gypsies working in Dublin with a performing bear in 1909. The other, *The Rest* or *The Hungarians,* was exhibited at the New English Art Club Summer exhibition in 1910.

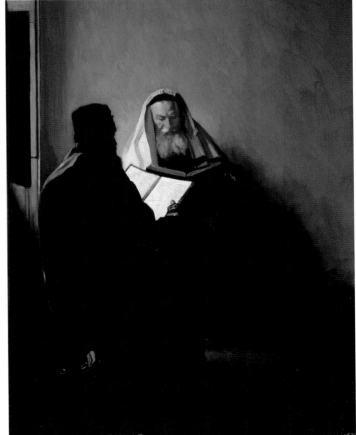

44

William Rothenstein
(1872–1945)

A Corner of the Talmud School, 1907
Oil on canvas
90 x 70.5 cm

With its robust composition and theatrical lighting this painting is typical of Rothenstein's palette in the 1900s. He painted a series of Jewish subjects based in a synagogue in Spitalfields, London, from 1904.

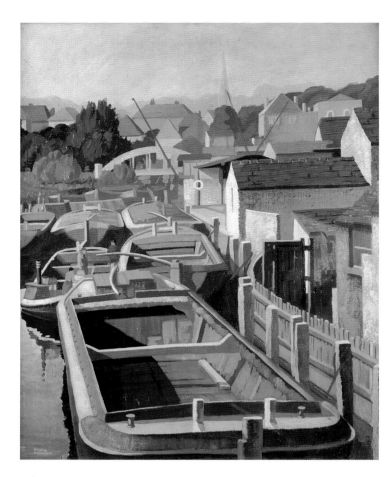

45

Harold Workman
(born 1897)

Barge Corner, c. 1937
Oil on canvas
75 x 62 cm

Workman was born in Oldham and trained at Manchester School of Art.
He was a member of the London Group and exhibited at the Royal
Academy and the New English Art Club. His subjects were mostly urban,
painted in subdued tones.

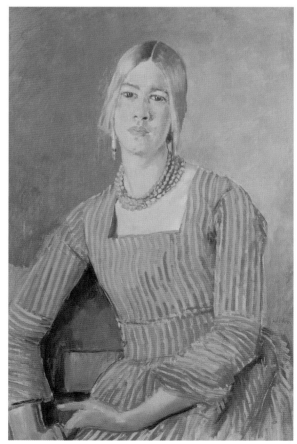

46

Augustus John
(1878–1961)

Eve Kirk, c. 1928
Oil on canvas
91.5 x 60 cm

This was described as "one of the most important additions yet made"
to the permanent collection of the Corporation of Rochdale when it was
acquired in 1946. Augustus John became the leading society portraitist
between the wars, diminishing his reputation among contemporaries and
subsequent critics. This portrait of Eve Kirk, a friend, falls more easily into
the group of portraits of family and friends which demonstrate John's feel
for the character of his subjects, as well as his skill as a draughtsman.
Kirk had trained as a painter at the Slade and John wrote a text for the
catalogue to her show at the Paterson Gallery in 1930. In 1955 she
moved to Italy and stopped painting.

47

Therese Lessore
(1884–1945)

Hop Gardens, Kent, 1935
Oil on canvas
91.5 x 60 cm

Lessore trained at the Slade School of Art. This is a good example of her decorative style, using formal elements for illusionistic effect. She mostly worked on small canvases, exploring aspects of everyday life. Though her work has sometimes been criticized for being merely derivative of Sickert's (she was his third wife) the two artists clearly had a mutual influence.

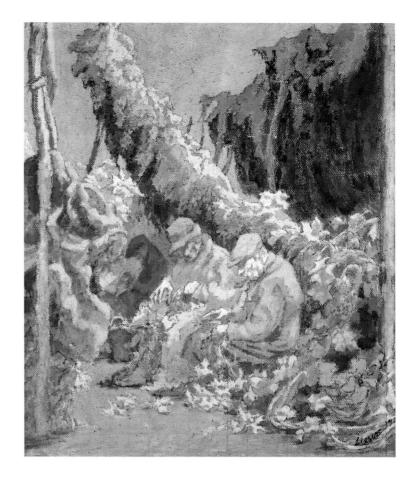

48

Laurence Stephen Lowry
(1887–1976)

Our Town, 1943
Oil on canvas
43 x 62 cm

This is a typical Lowry scene, in which patterned lines of diminutive figures are dwarfed by the rectilinear, monumental architecture. A fat man and two dancing figures stand out from the crowd – moments of mad individualism and oddity that are offset against the drab uniformity of urban life.

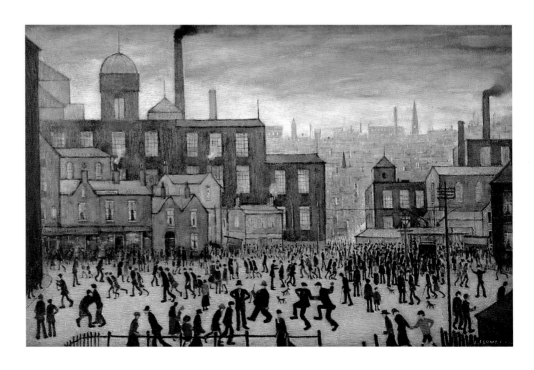

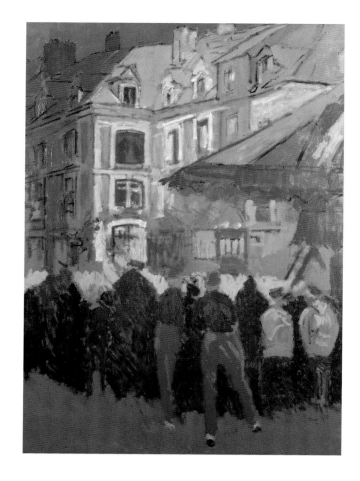

49

Walter Sickert
(1860–1942)

The Fair, Dieppe, c. 1902
Oil on canvas
129.5 x 97.2 cm

Sickert lived in Dieppe from 1899 to 1905 and immersed himself in the French art world. In around 1902 he was commissioned by M. Mantren to paint some large-scale works for his restaurant at Hotel de la Plage. This work was not part of that commission, but is the same size as the café pictures, suggesting that it may have been started with that commission in mind. Though unfinished, this night-time painting is typical of Sickert's work of this period in its limited range of flat colours and heavy outlines.

50

Stanley Spencer
(1891–1959)

Bellrope Meadow, Cookham, 1936
Oil on canvas
91.5 x 129.5 cm

Spencer often painted carefully observed landscapes linked to his figure paintings, and *Bellrope Meadow* is also the setting for *By the River* (1935). The decorative nature of this painting anticipates the heavier use of pattern that came to characterize much of his later, more mystical work.

51

Francis Campbell Cadell
(1883–1937)

Ben More in Mull, c. 1932
Oil on canvas
102 x 127 cm

As a young man Cadell was strongly influenced by the French Impressionists and Post-Impressionists. Though he is best known for his interiors Cadell also painted landscapes, inspired by the scenery of the Scottish Islands. Ben More is the highest mountain on the island of Mull in the Inner Hebrides.

52

Henry Lamb
(1883–1960)

Breton Youth, 1910
Oil on panel
41 x 33 cm

Henry Lamb lived in France as a young man, in 1910–11, and made a series of studies of Breton peasants, including this striking portrait. By this time he was under the spell of Augustus John, with whom he had spent a summer in 1907.

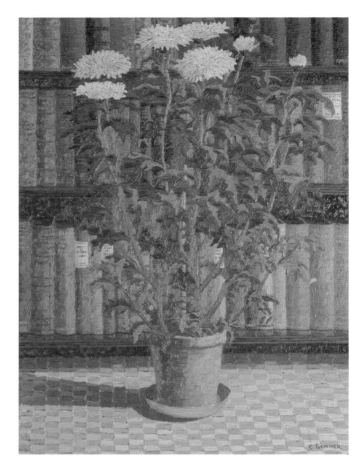

53

Charles Ginner
(1878–1952)

Yellow Chrysanthemums, 1929
Oil on canvas
76.2 x 55.9 cm

54

Charles Ginner
(1878–1952)

The French Novel or *The Mirror*, 1928
Oil on canvas
68.6 x 50.8 cm

Ginner has sometimes been identified as the 'Van Gogh' of British Post-Impressionism because of his intense feel for colour and paint. The use of warm and cold colours is typical of Post-Impressionist style, but his painting technique was in fact quite different. Ginner had a much tighter control of the paint than Van Gogh and constructed his pictures with mosaic-like blocks of impasto. Despite his professed loathing for formulaic painting, by this period Ginner's own style had itself become something of a formula.

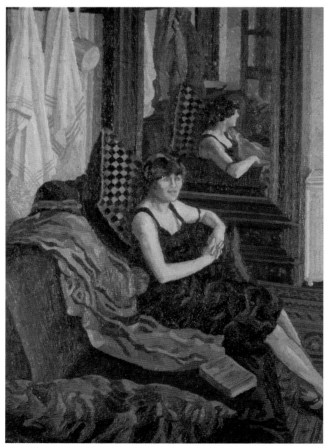

55

Hilda Carline
(1889–1950)

Swans, Cookham Bridge, 1935
Oil on canvas
38 x 76.6 cm

Carline was trained at the Slade School and exhibited at
the Royal Academy, with the New English Art Club and
with the London Group. *Swans, Cookham Bridge* was
painted after she had left Cookham and her divorce from
Stanley Spencer was imminent.

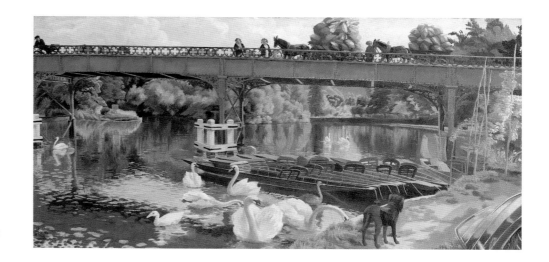

56

Walter Sickert
(1860–1942)

Two Women, 1911
Oil on canvas
52 x 41.6 cm

This work was painted in the year that Sickert had led the
more radical nucleus of the Fitzroy Street Group to form
the Camden Town Group. The two women are probably
Sarah and Alice Cook. They are wearing coster-mongers'
hats, such as were worn by porters at Covent Garden
Market.

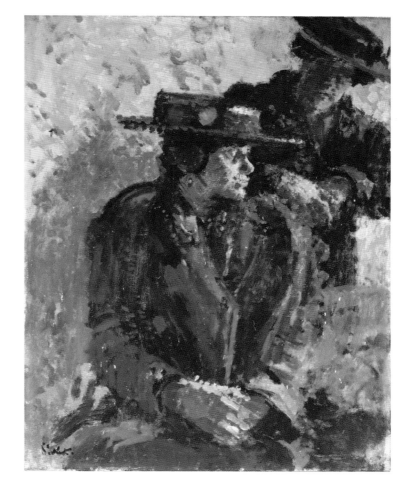

57

Stanley Spencer
(1891–1959)

Resurrection – The Hill of Zion, 1946
Oil on canvas
95 x 191 cm

During the Second World War, Spencer was employed as an official war artist to record shipbuilding in the Scottish town of Port Glasgow, a few miles west of the city of Glasgow. He completed an elaborate series of paintings on his official theme, but the town also triggered a response in him that was much more personal. Spencer was struck by the hill on which Port Glasgow cemetery is built, which reminded him of an upturned saucer. This, in turn, suggested a phrase of John Donne's in which the Resurrection is compared to "a king … climbing of the hill of Sion". With this in mind, Spencer proposed a fifty-foot-wide composition of the Resurrection in Port Glasgow cemetery, in which Christ would be shown sitting in Judgment, surrounded by angels, with the resurrected below. In the event, the plan was abandoned in favour of a series of smaller, independent canvases. *Resurrection – Hill of Zion* shows Christ seated on a low hill, amidst the angels and Prophets, whilst the newly risen people can be seen in the background.

The Avant-garde and Tradition

Bomberg	Nevinson	Freud
Craxton	Fry	Jones
Gertler	Nicholson	Sutherland
Morris	Hitchens	Ravilious
Nash	Roberts	
Morton	Grant	
Epstein	McWilliam	
Smith	Cole	

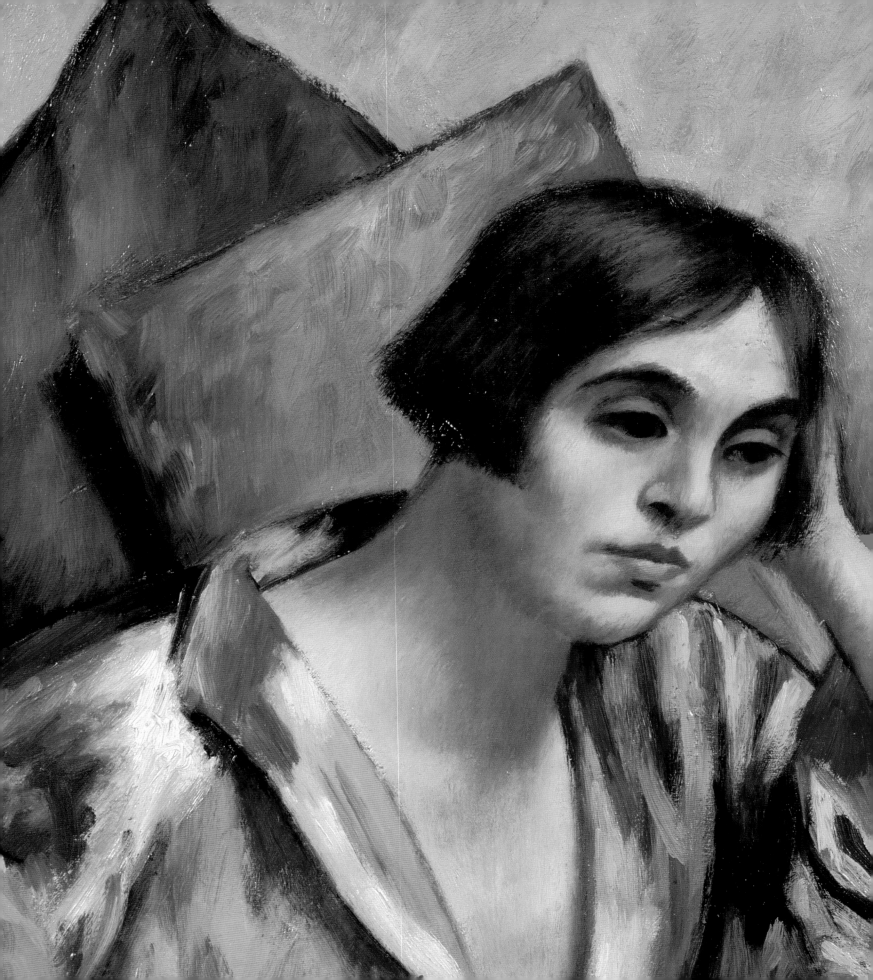

The Avant-garde and Tradition

by Francis Marshall

The four years between 1910 and 1914 saw the emergence in Britain of a vibrant avant-garde. Within the visual arts, work was being produced which, in its formal and intellectual rigour, rivalled anything being exhibited on the Continent. The detonator for this explosion of new thinking was Roger Fry's exhibition *Manet and the Post-Impressionists*,[1] held at the Grafton Galleries from November 1910 to January 1911. This exhibition,[2] and its follow-up, *The Second Post-Impressionist Exhibition of English, French and Russian Artists*, in October of 1911, revealed to young British artists the latest developments in European art on an unprecedented scale, prompting a far more dramatic break with tradition than had previously taken place.[3] Yet, in the aftermath of the First World War, this wave of creative energy seemed to have dissipated and the majority of the artists connected with it appeared to have retreated to the safety of the very tradition they had once so brusquely rejected.

That there should be a shift in focus was, under the circumstances, inevitable. The impact of the war was as devastating for the arts as it was for society as a whole. Before 1914, the most radical members of the avant-garde, particularly those who signed up to or sympathized with the Vorticist movement,[4] believed that abstraction should be the aim of art and the invigorating jolt of the city in the machine age should be its subject. It is hardly surprising, then, that, having experienced the full de-humanizing horror of industrialized warfare, these artists would reconsider their earlier opinions. Indeed, after the First World War, a call to order appears to have been sounded across Europe, as avant-garde artists began to adopt a less stridently experimental approach to their work. In France, for instance, Pablo Picasso and André Derain, to name but two, began to explore an up-dated classicism, whilst in Germany painters associated with *Neue Sachlichkeit* (New objectivity), among them Otto Dix, examined modern life using a language drawn from the art of the Northern Renaissance.

The nature of the change that overtook the arts in the wake of the First World War is well exemplified in four leading artists, David Bomberg, Jacob Epstein, Mark Gertler and William Roberts. With the exception of Epstein, these artists were exact contemporaries at the Slade School of Art, arriving there in 1908, two years before Fry introduced Continental Modernism to a public and art establishment that were both largely sceptical. The question is, how far, in fact, did these painters and sculptors drift from their Modernist ambitions? Was their post-war work an escape from modernity or rather an attempt at re-engagement with tradition via a Modernist aesthetic?

When, in 1929, David Bomberg painted *Toledo and the River Tajo* (cat 58) he was working in total obscurity. The man who had early created some of the most powerful images in Britain in a Modernist idiom, paintings such as *Ju-jitsu* of 1913, *In the Hold* of 1913–14 and *The Mud Bath* of 1914, had been largely forgotten by the British art establishment. In his early work, with its bold, pure colour and splintered grid structures, Bomberg came closer to

true abstraction than the majority of his contemporaries. Yet in the years immediately following the war he changed tack sharply, painting topographical landscapes in Palestine, abandoning altogether the bold experimentation of his youth.[5] The strain of his experiences in the war, coupled with a hostile reaction to his response to a Canadian War Memorials Fund commission, undoubtedly precipitated this change.[6] By the late 1920s, dissatisfied with his tightly literal landscape style, Bomberg began, again, to seek a new approach to picture making. As the English landscape did not interest him as a subject, he travelled to Toledo, in Spain, and it was there that he found the artistic voice of his maturity.

Toledo and the River Tajo is one of the finest examples of Bomberg's early Spanish period. The first impression it gives is of an immense rush of energy. Jagged brushstrokes of raw, unblended colour surge around the lower half of the painting and do not so much describe the cliffs above the river as create a visual equivalent for them. The city itself is rendered as a series of crystalline facets, like a nodule of quartz, bristling up from the plateau, the large number of spires and turrets serving to enhance the upward, aspiring movement of the image.

Here, and in Bomberg's mature style in general, the paint surface is rich, the brushwork varying between feathery *sfumato* effects, impatient jabs and energetic zigzags. Forms are treated broadly and emphasis is placed on rhythm rather than detail. Yet, despite appearances, *Toledo and the River Tajo* is every inch as organized as *The Mud Bath* of fifteen years before. Furthermore, Bomberg was fully aware of El Greco's extraordinary painting of a view of Toledo (Metropolitan Museum, New York). If El Greco provided the inspiration for this image, he also suggested the method for it, as Bomberg was later to point out:

> "From him you can learn that drawing and painting is one process and this is where the truth of life's structure comes in."[7]

Like his friend Bomberg, William Roberts began his career producing Vorticist abstractions before redefining his manner in the years following the war. The change in approach could hardly be more different, however, for, where Bomberg's work is restless and subjective, Roberts is calm and classical. Indeed, whereas David Bomberg, initially, rejected Modernism in favour of a fastidious naturalism, Roberts developed a form of applied Modernism which was to serve him, more or less unaltered, for the rest of his career.

The hallmarks of Roberts's work are a shallow space, flat planes of colour and a simplification of form. His figures have a chunky solidity, which has affinities with the work of Fernand Léger and Picasso. For subject-matter, the artist turned to daily life around him, often poking a little gentle fun at the foibles of the English. *Bath Night* (cat 74), which dates from 1930, is typical of much of Roberts's work. It shows a young boy being washed by his mother, whilst his father reads the newspaper. The focus on a scene from everyday, modern working-class life can be seen as an extension of his earlier fascination with the city. The sense of being in the small back room of a terrace house also has parallels with the kind of Mass Observation photographs taken in Bolton by Humphrey Spender after 1937.

Roberts's paintings are tightly designed. In *Bath Night* the eye is led around the painting by a series of subtly arranged rhythms. The angle of the mother's body, for instance, mirrors that of the son; her legs reflect the angle of the newspaper as well as the father's left arm; and the arrangement of arms, legs and feet sets up a series of counterbalanced horizontals and verticals. By concentrating on the formal qualities of the painting, Roberts manages to elevate an act as commonplace as washing in a tin bath to a dignified ritual.

Mark Gertler was a contemporary of both Roberts and Bomberg at the Slade School of Art. Although he did not serve in the war, Gertler produced one of British art's greatest responses to it, *The Merry Go-round*, in which a group of dummy-like figures, mouths open in either horror or exhilaration, revolve endlessly on a carousel.

The Bokhara Coat (cat 65), from Rochdale, is one of a number of paintings completed in 1920, at a time when Gertler was reassessing his practice. The sitter is Valentine Dobrée, an artist and designer he met in mid 1919. Despite her marriage to the literary critic Bonamy Dobrée, Gertler rapidly developed a close relationship with her.[8] The portrait of Valentine was made after a trip to Paris which the painter took with both her and her husband in March 1920. On his return, Gertler decided to paint only from nature and, by April, had taken a life model, and was simultaneously painting a portrait of Valentine, though this was later abandoned.[9] Subsequently, between May and July of that year, he completed the present portrait.

Valentine is shown leaning her head on her left hand, resting her elbow on the edge of a polygonal table upon which sits a coffee cup. The perspective has been skewed, so that we seem to be looking down into the chair. Space is extremely shallow, the pearly grey background flattening the image, pushing the sitter up to the very front of the picture plane. The effect is claustrophobic, uncomfortable. Even the cushions seem to jostle the sitter.

Gertler's attitude to French art, which at the time was regarded by many in England as the fountainhead of all things modern, was ambiguous. Whilst he very clearly did feel an affinity with both Cézanne and Renoir (the sturdy forms of his figures derive from these men) his attitude to younger artists was more reserved. He referred to an exhibition of recent French art held in 1919 as making him feel as if he "were on the stage".[10] No doubt this was partly a reaction to the enthusiasms of the Bloomsbury group, with whom he was associated, but from whom he nevertheless kept his distance.[11] It also reflects Gertler's response to Modernism in general. On the other hand, it is entirely in keeping with his own remark,

> "When a Bird [*sic*] is inspired it sings – it sings. It does not wonder if its manner of singing is different to a bird that sang a thousand years ago – it just sings."

A discussion of Jacob Epstein's approach to Modernism is complicated by the sculptor's use of two distinct styles concurrently throughout his career. Broadly speaking, his early work was influenced by the arts of Africa and the ancient Near East. It was characterized by a simplification of forms and use of distortion which reached its most radical manifestation in *The Rock Drill* of 1913, in which a hunched mechanoid bestrode a real rock drill. After this, he began to pull back from such an extreme vision, believing that

> "… to think of abstraction as an end in itself is undoubtedly letting oneself be led into a cul-de-sac, and can only lead to exhaustion and impotence".[12]

Nevertheless, Epstein continued to use a similar approach for large-scale and public work. In 1912, at around the time he conceived *The Rock Drill*, he made *Self-portrait in a Storm-cap*, now in the collection of the Harris Museum and Art Gallery (cat 78), an example of the warmer, more humanistic style he would develop after the war. It is, though, one which is still informed by a Modernist sensibility. The sitter's features are rendered naturalistically enough, but with a vigour and abbreviation of form which lends the head a startling physical presence. Subsequently, Epstein refined this approach, almost to the point of mannerism, in a series of portraits of leading public figures of the day, such as Albert Einstein and Winston Churchill.

Nevertheless, in more personal work, such as *Zeda (Pasha)* (cat 66), he continued to produce images exploring sexuality and the naked body which are distinctly modern in content. The physical frankness of his work in this vein has little precedent in British art. Before the nineteenth century, the nude, whether male or female, appears only rarely and, when it does appear in the later nineteenth century in the work of painters such as Leighton, the classical context and idealization of the figure tend to provide it with a degree of respectability. In contrast, Epstein's bronzes, with their roughly worked surfaces revealing the movement of the artist's hands, seem to quiver with life. Undoubtedly, his attitude both to the figure and to his material is due to the influence of Rodin, who sought to capture the subtle shifts in form of the living figure by means of highly spontaneous sketches and studies. Rodin was important for Epstein long before Modernism and remained central to his way of thinking at all times. Seen in this context, his portraits and figure studies take on a different implication. Epstein's Modernism always involved a dialogue with, rather than a simple rejection of, tradition.

In the aftermath of the First World War, many artists began to react against grand gestures, attitudinizing or tub-thumping of any sort, whether from politicians or art theorists. This was coupled with a need to re-engage with human subject-matter, or at any rate to move away from a machine-inspired abstraction.

As we have seen, Bomberg's post-Toledo paintings are not about what the landscape looks like so much as what it feels like to be within it. The assertive paint surface becomes a record of an event – the artist's attempt to convey his experience of the landscape. Similarly, Roberts uses a form of Modernist classicism to dignify the events of everyday life. If Roberts's work is essentially tranquil, Gertler's paintings suggest a sense of psychological unease and could almost serve as an illustration to the poetry of T.S. Eliot.[13] The pitted surfaces of Epstein's bronzes are a result of their construction and, as such, exemplify the Modernist dictum of 'truth to materials'. Indeed, the work of these artists is a constant reminder of their grounding in Modernism and of their ambition to forge a new language in art.

1. The exhibition contained work by Cézanne, Van Gogh and Gauguin, as well as examples by younger artists such as Picasso and Matisse. Fry was both a critic and a painter. However, his influence was greatest as a theorist and apologist for Modernism.
2. Continental avant-garde art had been exhibited in London before this date but the impact of Fry's exhibition was due not just to the sheer number of works shown but to his argument that the artists included were a major new movement in art.
3. Sickert and the other members of the Camden Town Group represent the beginnings of the modern movement in England. Their work was, though, essentially a development of French painting from the late nineteenth century rather than an engagement with contemporary ideas then emanating from Europe.
4. Founded by Wyndham Lewis, the Vorticists included the poet Ezra Pound, the painters William Roberts, Helen Saunders and Edward Wadsworth, and the sculptor Henri Gaudier-Brzeska, amongst others. The movement, one of England's most original contributions to European modernism, fused elements of Cubism, Expressionism and Dada.
5. One visitor to an exhibition of Bomberg's Palestine paintings was prompted to ask, "What happened to the wild trumpeter?" (Richard Cork, *David Bomberg*, London 1988, p. 92).
6. The critic P.G. Konody described the painting *Sappers at Work*, as "a futurist abortion" despite Bomberg's deliberate efforts to work in a style acceptable to the commissioners (*ibid.*, p. 22).
7. *Ibid.*, p. 30.
8. The full extent of the relationship is not clear, though Gertler hints at intimacy. See Sarah MacDougall, *Mark Gertler*, London (John Murray) 2002, p. 187.
9. Both the model and Valentine fell ill and were unable to pose (*ibid.*, p. 190).
10. Letter to S.S. Kotiliansky, cited *ibid.*, p. 184.
11. In contrast to the upper-middle-class Bloomsbury artist, Gertler, the son of working-class Jewish immigrants, was brought up in Austria and the East End of London.
12. Jacob Epstein, *Let There Be Sculpture*, London 1942, p. 57.
13. Gertler most probably met Eliot at Garsington in 1916 (Peter Ackroyd, *T.S. Eliot*, London 1984, p. 76). Certainly the two men knew each other, for Eliot, along with various other writers, attended parties at Gertler's house in 1930 (MacDougall 2002, p. 267).

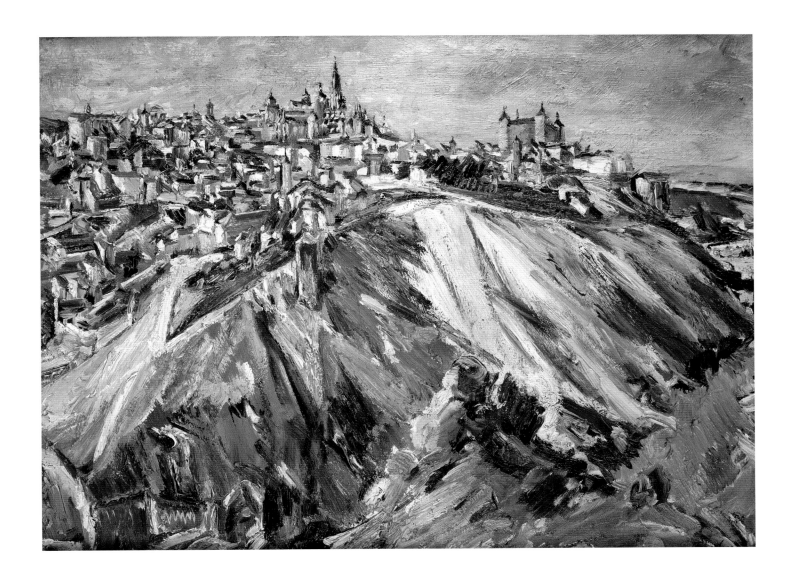

58

David Bomberg
(1890–1957)

Toledo and the River Tajo, 1929
Oil on canvas
58.4 x 76.2 cm

Bomberg's middle-period landscapes reveal a stylistic transition between Vorticist angularity and a more personal, Expressionistic approach characterized by heavily impastoed, gestural brushstrokes. The city of Toledo is depicted in a more or less naturalistic manner, whilst the escarpment is built up from a series of marks which do not so much describe as provide a pictorial equivalent for the rock face.

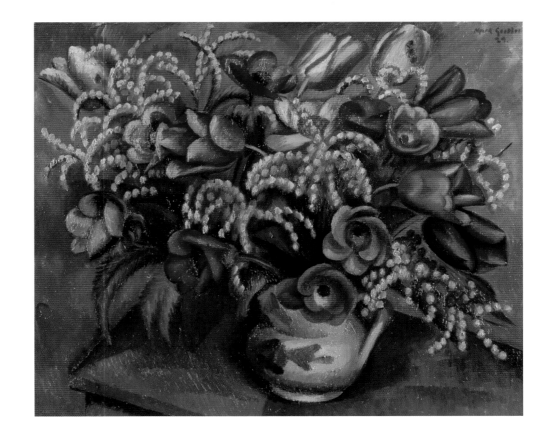

59

Mark Gertler
(1891–1939)
Tulips and Mimosa, 1929
Oil on canvas
62.2 x 75 cm

60

Cedric Morris
(1889–1982)
Harding Down, Llangennydd, 1928
Oil on canvas
61 x 75 cm

61

John Northcote Nash
(1893–1977)
Oaks by the Sea, c. 1945
Watercolour on paper
44 x 56.5 cm

62

Paul Nash
(1889–1946)
Vale in Gloucestershire, 1945
Watercolour and oil on board
56 x 76.3 cm

63

Alistair Morton
(1910–1963)

Abstract, 1946
Watercolour and ink on paper
39.4 x 37 cm

Morton was born in Carlisle and studied at Edinburgh
University and Balliol College, Oxford. In 1932, he
became director of Morton Sundour, based in Carlisle.
From this position, in 1937, he launched Constructivist
Fabrics, using designs by Ben Nicholson and Barbara
Hepworth, amongst others. His own large-scale abstract
textile patterns were highly celebrated during the 1950s.
Between 1936 and 1962 he exhibited his abstract
paintings at the Lefevre Gallery in London.

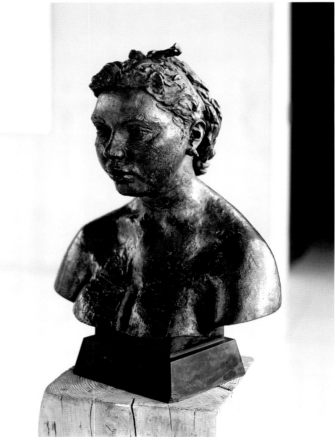

64

Jacob Epstein
(1880–1959)

Peggy Jean, 1935
Bronze
58 cm

Peggy Jean was Epstein's daughter. He made
numerous portraits of her throughout her life.

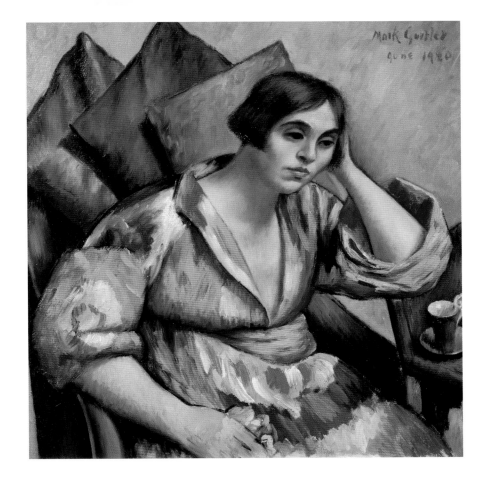

65

Mark Gertler
(1891–1939)
The Bokhara Coat, 1920
Oil on canvas
71 x 71 cm

The Bokhara Coat is a portrait of Gertler's close friend
Valentine Dobrée. Gertler had visited Paris with Dobrée
and her husband in March 1920. Whilst there, he took
the opportunity to study the works of Cézanne and
Renoir. Although he had hitherto been most interested in
the former, the latter was to be a decisive influence on
his subsequent development. The simplified, heavy
forms and warm colours of *The Bokhara Coat,* for
instance, although very much Gertler's own, are a
response to the later work of Renoir.

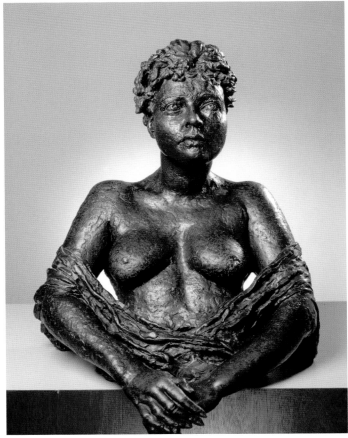

66

Jacob Epstein
(1859–1929)
Zeda (Pasha), 1927
Bronze
68.5 cm

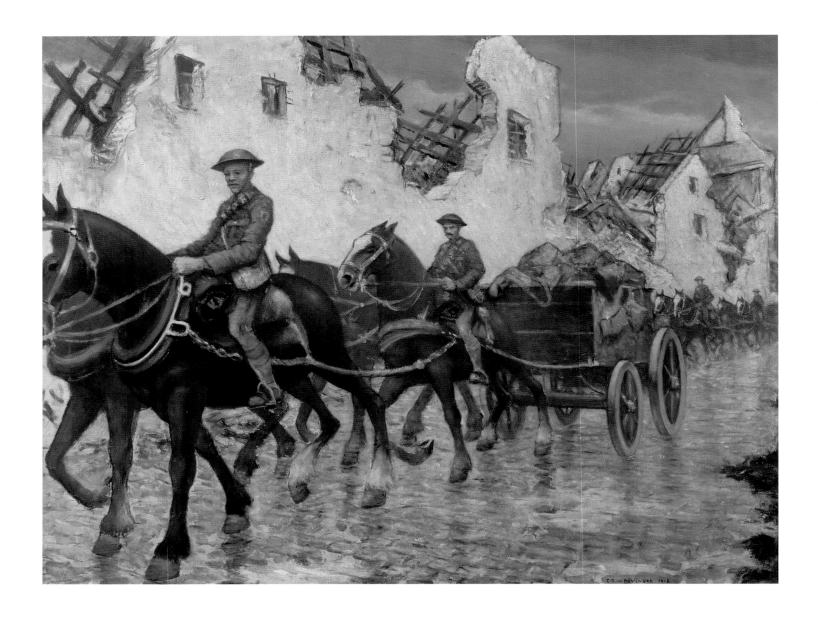

67

Christopher R.W. Nevinson
(1889–1946)

After the Capture at Bapaume, 1918
Oil on canvas
71 x 94 cm

Nevinson was sent to record the war by the British Government and was made an official war artist in 1916. His early war work retained a harsh, sharply defined, planar style which is clearly still Vorticist in spirit. However, *After the Capture of Bapaume* exhibits a remarkable degree of naturalism, which may be due to his working officially.

68

Matthew Smith
(1879–1959)
Blue Vase with Fruit, c. 1950
Oil on canvas
63.5 x 76.5 cm

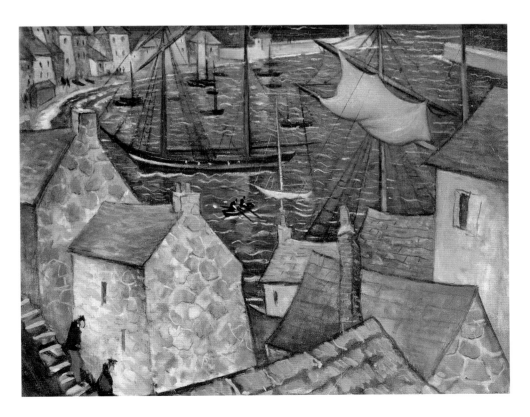

69

Christopher R.W. Nevinson
(1889–1946)
The Old Harbour, c. 1930
Oil on canvas
40.5 x 51 cm

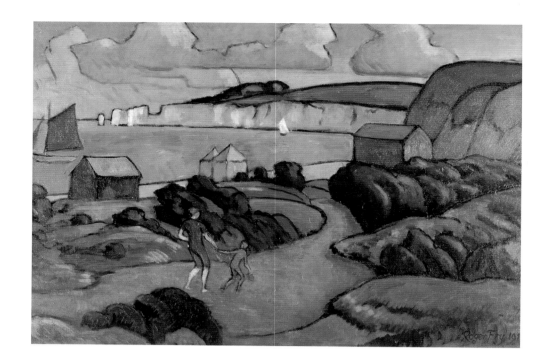

70

Roger Fry
(1886–1934)

Studland Bay, Dorset, 1911
Oil on canvas
62 x 92 cm

During the period 1910–14 Fry created some of his most overtly Modernist paintings. In a work such as *Studland Bay,* the landscape is depicted as a series of flat, angular planes rendered in vibrant, non-naturalistic colours. The forms have been radically simplified and are defined by strong, graphic contours.

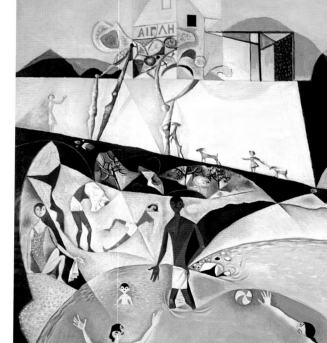

71

John Craxton
(born 1922)

Beach Scene, 1949
Oil on canvas
58.4 x 76.2 cm

72

Ben Nicholson
(1894–1982)

Cornish Landscape, 1940
Oil, tempera, pencil and relief
25.4 x 35.6 cm

Between 1939 and 1946 Nicholson made a series of
paintings of farm buildings with a background of the sea,
in which form and colour are simplified. The artist called
this "nursery realism". The Second World War was a
period of reassessment for Nicholson, as he turned
away from pure white abstract reliefs to more naturalistic,
though stylized, landscape paintings.

73

Ivon Hitchens
(1893–1979)

Still Life with Poppies, c. 1940–45
Oil on canvas
81 x 62 cm

Although Hitchens is known primarily as a landscape
painter, he also painted figure studies and still lifes.
Flowers, in particular, provided a form of relaxation after
being outdoors painting the landscape in all weathers.
This is one of a number of flower studies the artist made
during the 1940s. Hitchens wrote, in an undated note: "I
love flowers. I love flowers for painting One can read
into a good flower picture the same problems that one
faces with a landscape, near and far, meanings and
movements of shapes and brushstrokes. You keep
playing with the object."

74

William Patrick Roberts
(1895–1980)
Bath Night, c. 1930
Oil on canvas
40.5 x 51 cm

Roberts, the Vorticist, developed an angular style which reveals
the influence of African carving. Later, this was modified and
figures are depicted as heavily built with tubular limbs, in a style
which owes something to the classicism of Picasso and the
work of Fernand Léger. Once he had defined this approach,
Roberts did not deviate from it for the rest of his career.

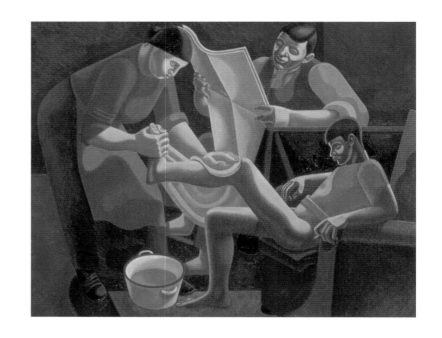

75

Duncan Grant
(1885–1978)
The Gossips, 1925
Oil on board
81.4 x 56 cm

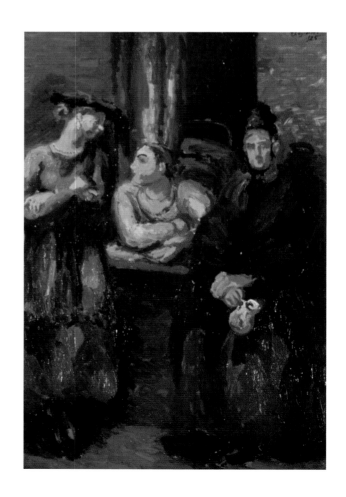

76

Fred McWilliam
(1909–1992)
Angular Figure, 1934
Cherrywood
104 cm

77

Leslie Cole
(born 1910)
R.A.F. Bomb Dump, Malta, 1943
Watercolour on paper
50.5 x 72.2 cm

In August 1942, the War Artists Advisory Committee
decided to send Cole, then a tutor at Hull College of Art,
to Malta, though he did not arrive there until May 1943.
Besides recording the work of the Army, Navy and R.A.F.,
he made many drawings of the Maltese themselves, in
acknowledgement of their contribution to the defence of
the island.

78

Jacob Epstein
(1880–1959)

Self-portrait in a Storm-cap, 1912
Bronze
49 cm

Epstein developed two distinct approaches to sculpture,
which are excellent examples of the Modernist dictum of
'truth to materials'. When carving, he used an angular
style derived from his study of African and Western Asian
art. Indeed, the physical nature of stone, which must be
carved, favours a broad, planar treatment of form.
Bronze, however, which is simply a reproduction of
original work in a malleable material like clay or wax, is
ideal for picking up the traces of nimble fingers moulding
the image into shape.

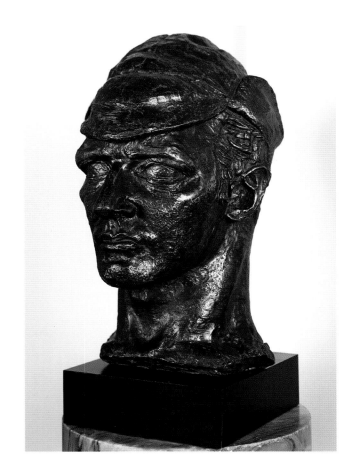

79

David Jones
(1895–1974)

Haystooks, Matterdale, 1946
Pencil and watercolour
45 x 58 cm

David Jones was both an artist and a poet. His two
books *In Parenthesis* and *Anathemata* are amongst the
most significant works in English in a Modernist idiom.
As an artist, he trained initially at Camberwell School of
Art before seeing active service in the Frist World War. In
1921, he converted to Catholicism and, until 1927,
worked closely with the sculptor, Eric Gill.

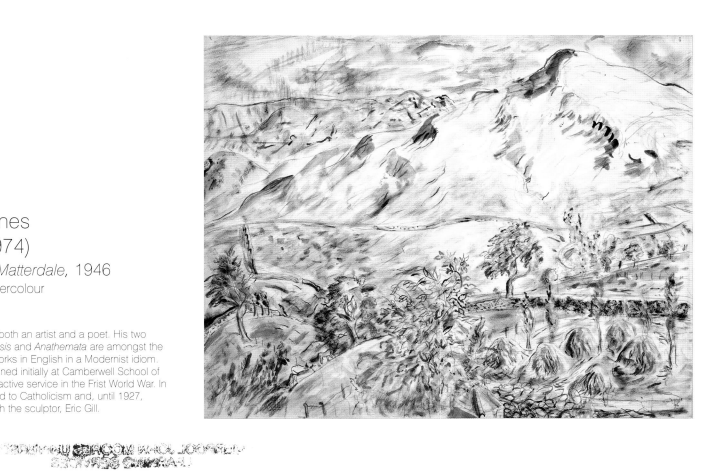

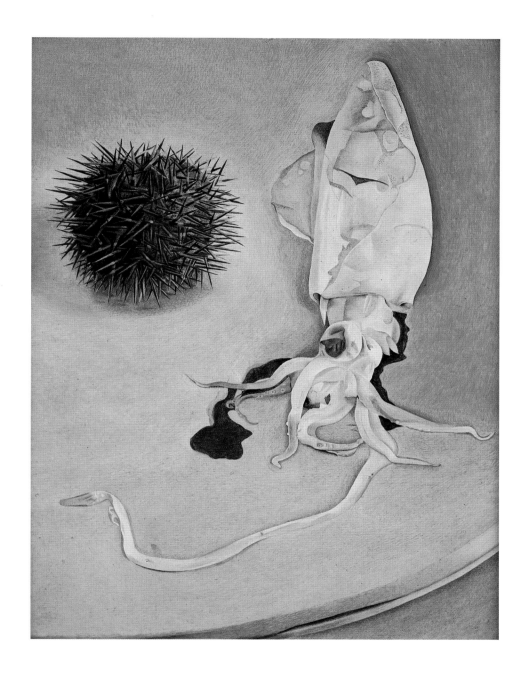

80

Lucian Freud
(born 1922)

Still Life with Squid and Sea-urchin, 1949
Oil on copper
30 x 23 cm

Lucian Freud was one of several artists, including Francis Bacon and Frank Auerbach, who came to prominence after the Second World War. Their work was resolutely figurative at a time when the general international tendency was towards abstraction. Freud's work of this period is notable for its immaculate finish and acutely observed realism, which led Herbert Read to refer to him as "the Ingres of Existentialism". The contrast between the spiky sea-urchin and the slack squid in the present picture lends it an uneasy atmosphere of subtle menace or disquiet.

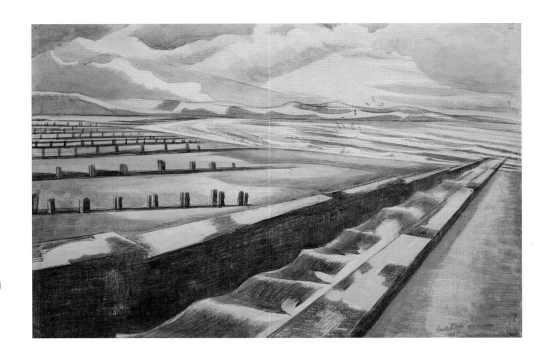

81

Paul Nash
(1889–1946)

Channel and Breakwater, 1923
Watercolour, pencil and crayon on paper
36.7 x 55.7 cm

In 1921, Nash suffered a nervous breakdown which was
attributed largely to the war. Upon his release from
hospital, he took a cottage in the Kent village of
Dymchurch and there, over the next few years, produced
a series of drawings and paintings of the South Coast.
The majority of these works are notable for the contrasts
made between natural forms, such as the sea, and the
man-made breakwaters and sea walls.

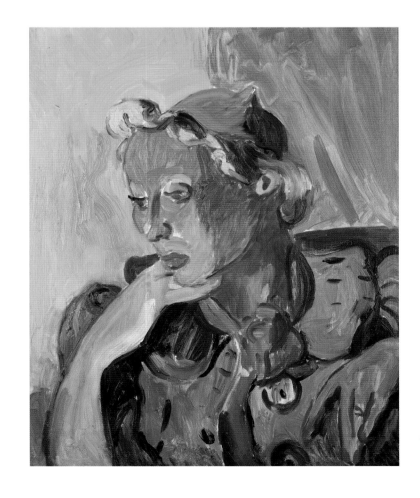

82

Matthew Smith
(1879–1959)

Reflections, c. 1940
Oil on canvas
64.8 x 54.5 cm

Between 1910 and 1911, the Yorkshire-born Smith had
lived in Paris where, briefly, he studied under Henri
Matisse. His understanding of French art, particularly the
work of Gauguin and Delacroix, led him to develop a
pictorial language which combined intense colour,
simplified forms and loose brushwork.

83

Graham Sutherland
(1903–1980)

Rocky Landscape with Sullen Sky, 1940
Oil on canvas
49.3 x 69.5 cm

Sutherland's early work was deeply influenced by the work of
Samuel Palmer. The treatment of landscape to evoke a
poetic mood and spiritual atmosphere remained an
important aspect of his art. The present drawing probably
depicts the landscape around Crickhowell in Southern
Wales.

84

Eric Ravilious
(1903–1942)

The Yellow Funnel, c. 1938
Watercolour on paper
43 x 58.5 cm

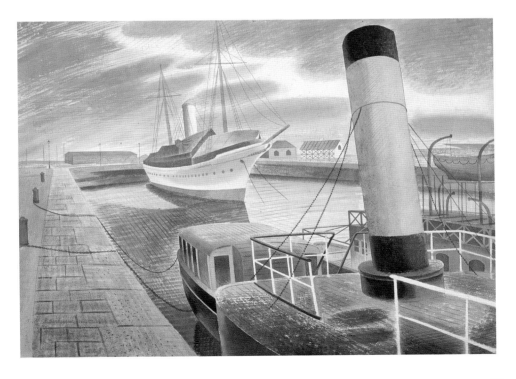

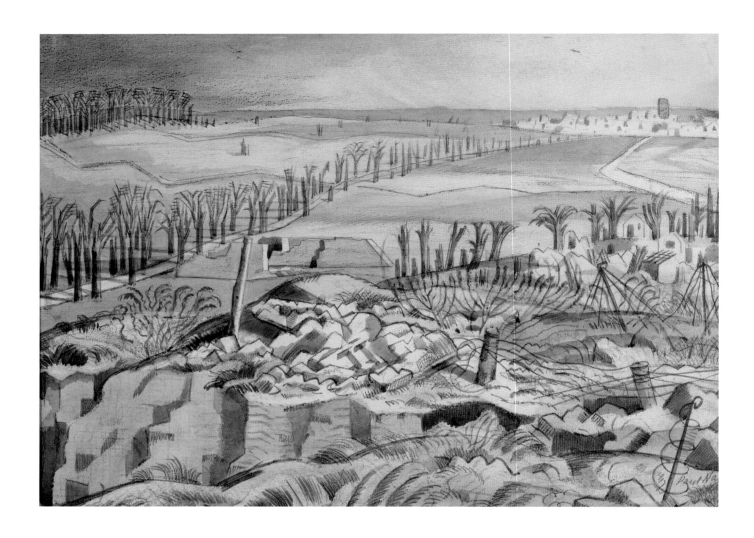

85

Paul Nash
(1889–1946)

Vimy Ridge, 1917
Watercolour and pencil on paper
25.6 x 35.2 cm

Unlike his Slade contemporaries, Nevinson and Bomberg, Nash showed little interest in experimental
art before 1914. However, by 1917 he had developed a tough, pared-down method, one which was
particularly suited to depicting the unprecedented devastation he experienced on the battlefields of
Flanders. In November 1917, Nash wrote to his wife: "I am no longer an artist interested and curious.
I am a messenger who will bring back word from the men who are fighting to those who want the war
to go on forever. Feeble, inarticulate will be my message, but it will have a bitter truth and may it burn
their lousy souls."

"Canvas-Free Artists"
Studio Pottery in Britain

Leach	Terry
Cardew	Washington
Martin Brothers	Pleydell-Bouverie
Dalton	Staite Murray
Vyse	
Braden	

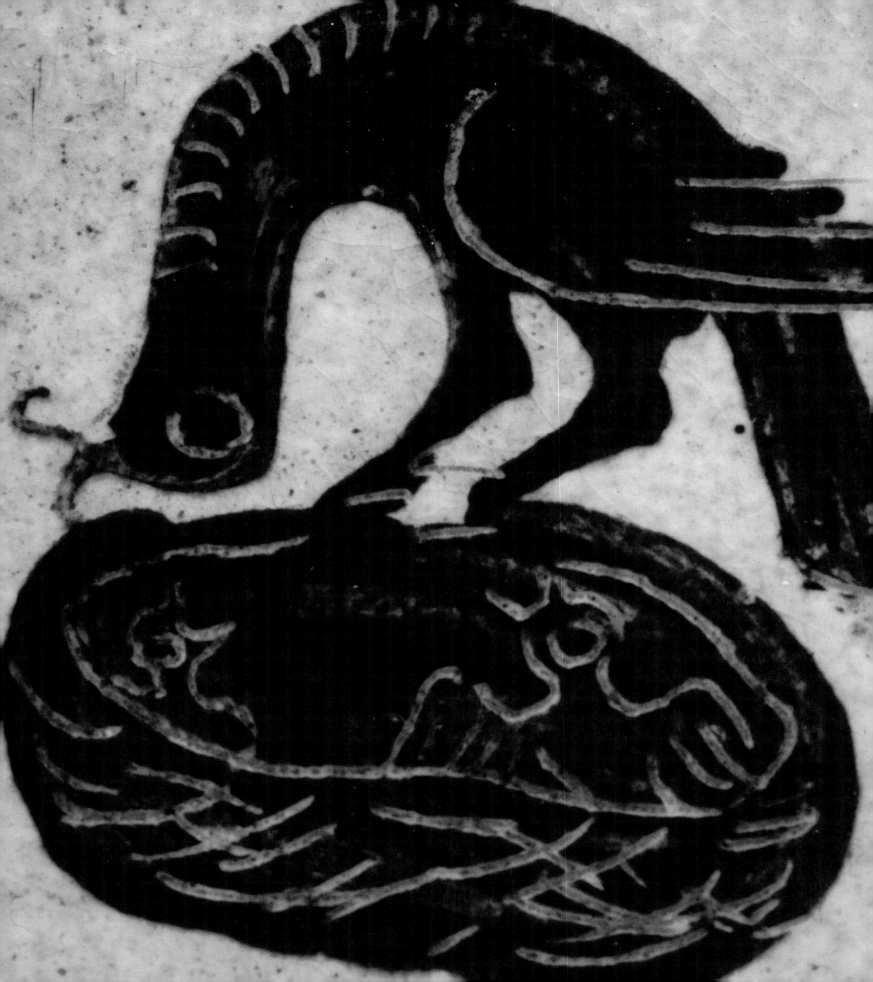

"Canvas-Free Artists"
Studio pottery in Britain

by Dinah Winch

In 1910 two London exhibitions had a seminal impact on the British art world. One, Roger Fry's first Post-Impressionist exhibition at the Grafton Galleries, included ceramics by Matisse, Derain and Vlaminck, among others; the other was an exhibition of Chinese pots from the Tang (618–907), Song (960–1279) and Yuan (1280–1368) dynasties, held at the Burlington Fine Arts Club. Both exhibitions provoked new thinking about form and its place in modern aesthetics, with Fry arguing that the strong sense of form of the Chinese pots ranked them alongside painting and sculpture. Europeans were of course familiar with later porcelains but these earlier stonewares, excavated around the turn of the century when the Chinese railways were being built, were of a dramatically different character. Though not always technically perfect they were recognised as expressions of individual creativity. Much of their beauty came from their simplicity of form and the intrinsic qualities of their glazes, described in the catalogue as ranging from "thin diaphanous gloss to a thick, unctuous coating which the Chinese were never tired of comparing to 'massed lard'".[1] This exhibition not only inspired a number of young artists to turn to making pottery but helped to make the British art world receptive to a new artistic medium.

Studio pottery was arguably one of the most important and influential artistic movements to emerge in Britain before the Second World War. It was often described as a form of sculpture, or a link between painting and sculpture. Charles Marriott, art critic on The Times, described pottery in 1943 as "precisely, abstract sculpture" and argued that, while there were no British sculptors working to match Brancusi, British studio potters were "second to none", exerting international influence.[2] Art historians may, on the whole, have written studio pottery out of the story of British art but, as Tanya Harrod has recently pointed out, an interest in studio pottery, with its ambiguous status in the hierarchy of the arts, became a marker of modernity for artistic people in the 1920s and 1930s.[3] Artists could position themselves outside the art establishment by experimenting with art forms other than painting, from studio pottery to industrial design. The most obvious example of this is Roger Fry's Omega project, but other artists who became engaged in the 'applied arts' included Paul Nash (Unit One) and Ben Nicholson, who designed for Foley China and collaborated with Barbara Hepworth to create 'Constructivist textiles' for Edinburgh Weavers.

Studio pottery has various roots, most notably in the Arts and Crafts movement, but, unlike other modern movements, no coherent pre-history. The idea of the studio potter as a hands-on maker, who controlled the process from conception to creation (as opposed to an artist whose designs were carried out by others), emerged in late nineteenth-century France and the United States. The Martin brothers (cat 93) are often identified as the first British studio potters because they worked closely together in their London studio, creating pots from

conception to production and decoration. However, the main catalyst for the emergence of the artistic language of studio pottery in Britain was exposure to East Asian pottery traditions. William Dalton was one of the pioneers of studio pottery and the small grey bowl in the Gallery Oldham collection (cat 89) is typical of early studio pottery in the Chinese aesthetic. It also epitomizes the abstract qualities that appealed to Western Modernists.

Pottery was not taught in British art schools until 1909, when Dalton established a pottery class at the Camberwell School of Arts and Crafts. His students included Roger Fry, Reginald Wells, Charles and Nell Vyse and William Staite Murray. Nell Vyse was trained as a chemist and was an important pioneer in the re-creation of Chinese glazes, while her husband Charles, who had trained as a sculptor at the Royal College of Art, made their pots and figures (cat 100). However, their rather literal interpretation of the Chinese aesthetic was seen by their peers, and some critics, as lacking in artistry at a time when studio potters were trying to assert their status within the art world.

In 1925 William Staite Murray argued that "it is through the artist's vision that pottery is again a vital force".[4] Murray was the most powerful advocate of the idea that studio potters were independent artists who created works of individual expression. After studying at the Royal College of Art Murray worked alongside the Vorticist Cuthbert Hamilton at Yeoman's Row in Chelsea making pots decorated with Modernist abstract designs. In 1919 he set up his own pottery, creating pots in the Song-inspired style of simple shapes with subtle glazes and exploring abstraction through three-dimensional form: "Didactically pottery has a definite mission in form sensibility development. The forms are abstractions and as such readily contemplated as pure form."[5] Pottery, significantly, was described by Herbert Read as a new medium rather than a new movement, and in 1930 he described potters as "canvas-free artists".[6] The idea of this new medium as a link between painting and sculpture became something of a commonplace among critics, who were intrigued by its place in the canon in a period when avant-garde painting and sculpture were moving away from figuration and representation.[7] In the 1920s Staite Murray moved within London's avant-garde artistic circles, exhibiting not only in solo shows in London art galleries but alongside the painters Cedric Morris, Christopher Wood and Winifred and Ben Nicholson. In 1927 Ben Nicholson nominated him to exhibit with the avant-garde 7 & 5 Society and he exhibited in the seminal "all abstract" show of 1935 alongside Nicholson, Barbara Hepworth, Ivon Hitchens, Roland Penrose and others.

Staite Murray was collected not only by a small band of pottery connoisseurs, like Eric Milner-White, but also, by the late 1920s, by collectors of Modernist art such as J. Ede and Helen Sutherland. The 1927 Annual Report of the Contemporary Art Society lists a blue-grey jar by Staite Murray among the gifts presented to it. Unfortunately, the Contemporary Art Society archive does not record any debate about the ambiguous status of this work as an art object, but later that year Ernest Marsh, a member of the Contemporary Art Society committee and collector of Martinware, initiated a Pottery and Craft fund and the pot was transferred to this collection. The vast majority of purchases made by the Fund were of contemporary British pottery and throughout the 1930s Contemporary Art Society exhibitions included pots alongside paintings and sculpture. The nucleus of many public studio pottery collections across Britain, including that of Gallery Oldham, came from this fund.

Alongside Staite Murray the other major figure of early studio pottery was Bernard Leach, who had discovered pottery while working as an etcher in Japan. In 1923 an exhibition of the work of Leach and others opened in Japan and a critic commented: "We admire your stoneware (in the Oriental mode) but we love your English slip-ware – born not made".[8] Many of Leach and Shoji Hamada's early wares produced at St Ives were inspired by local vernacular vessels such as galena-glazed tankards and slipware jugs, made for the local tourist trade and for Japan, where there was great demand for these exotic, and paradoxically modern, wares. Leach, though profoundly influenced by East Asian culture, had a strong sense of the importance of a British tradition in his

work. This was part of an evolving concept of 'appropriateness' that became one of the tenets of Leach's philosophy and distinguished him from Staite Murray. He returned to historic English shapes and methods of decoration throughout his career (cat 90) while his pupil Michael Cardew excelled in making slip-decorated earthenwares (cat 88) in a masterful fusion of traditional and modern aesthetics. Cardew became the most important potter of his generation working outside the Chinese-inspired idiom. This very English strand within British studio pottery was an important part of its identity as a *British* art form, albeit hugely influenced by Asian traditions. Another important element of 'appropriateness' for many potters was a direct relationship with nature. Hamada had led the way, restricting himself to using only local clays and glazes made from the raw materials of his local environment in Japan. In Britain Katharine Pleydell-Bouverie (cat 97 and 98) and Norah Braden (cat 86 and 87) made pioneering experiments with ash glazes using materials found on the Coleshill estate.

While Staite Murray and his pupils – including Robert Washington (cat 101) and Marjorie Terry (cat 99) – may have seen themselves as 'modern' artists, all potters engaged to some extent with the critical issues of modernism: these included exploring the innate beauty and characteristics of the medium (clay, glaze), 'truth to materials', the relationship between creative or artistic practice and industry (studio versus commercial pottery) and the articulation of the definition of art and the artist's role in society. The tenets of the 'Leach School' as set out in *A Potter's Book* (published in May 1940) included the concepts of 'fitness of purpose' and 'truth to materials', which for the potter meant that forms should evolve organically from the clay, rather than imitate other materials, and that the glaze should look like molten stone. The work of Braden and Pleydell-Bouverie, both students of Leach, synthesized Chinese influence as mediated through Leach, modernist aesthetics and the practical realities of potting. They made quiet but muscular pots decorated with subtle glazes and both had an instinctive feel for form. Braden in particular decorated her pots with brushwork (cat 86) which at its best evolves organically from the form of the pot, rather than using the surface of the pot as a 'canvas'.

The question of function is critical to the distinction between art and craft but the meaning of function was not clear-cut in this period. Read was perhaps being self-consciously 'modern' when he stated that "if an object … perfectly fulfils its function … it is automatically a work of art".[9] However, this position was not that far from the Japanese-inspired vision of the relationship between art and utility that emerged in Leach's thinking in the 1930s. In 1929 Hamada and the Japanese critic Yanagi Soetsu introduced him to the Japanese concept of *mingei*, which was the foundation of a very different understanding of 'fitness for purpose'. Yanagi wrote that Hamada had recognised that "the beauty of pottery finds its fullest expression only when it is joined to utility".[10] In Japan objects were expected to fulfil not only spiritual and aesthetic but also utilitarian purposes. Leach later noted his "conviction that pots must be made in answer to outward as well as inward need", and added that this "determined us to counterbalance the exhibition of expensive personal pottery by a basic production of what we called domestic ware", which was known as Standard Ware and began to be produced in the late 1930s.[11] Leach had been moving towards this position since the late 1920s, when the St Ives Pottery began to produce cheap decorative tiles (cat 92) in order to shore up its precarious finances.

In 1936 Oldham Art Gallery purchased a small green pot by Leach (cat 91) from The Little Gallery, its first acquisition of studio pottery and the most functional piece in the collection. The Little Gallery was part of a distinct 'craft world' that began to emerge in the 1930s, catering, in Edmund de Waal's words, "less for a collecting than for a decorating public" and stocking items like artist-designed wallpapers and commercial ceramics.

In 1928 Leach appeared to repudiate the idea of the potter as artist: "Working by hand to please ourselves as artists first and therefore producing only limited and expensive pieces, we have been supported by collectors, purists, cranks or 'arty' people, rather than by the normal man or woman … and consequently most of our pots

have been stillborn: they have not had the breath of reality in them: it has been a game."[12] Leach's emerging philosophy accelerated this inbuilt creative tension between art and craft, a tension which was also reflected in the practice of the Contemporary Art Society. Ernest Marsh's death in early 1945 precipitated some uncertainty as to how to proceed with the Pottery and Craft Fund.[13] Cecilia Dunbar, Lady Sempill, the founder of Dunbar Hay Ltd, was co-opted as a specialist buyer, though she soon resigned and the Fund was wound up in 1947. The minute of this decision appears to keep alive the possibility of acquiring craft in the future: "the fund would not continue (in so far as maintaining a special Fund for this specific purpose is concerned)".[14] However, the following year Lady Sempill suggested that the Contemporary Art Society purchase some furniture painted by Eric Ravilious, a suggestion that was refused on the grounds that the Fund no longer existed and therefore the furniture was "not within the province of the CAS". Yet the Society accepted some samplers that she presented, suggesting that they were happy to sit on the fence that divided fine art from craft, at least when none of their own funds were changing hands.

Within the studio-pottery world itself commercial expediency was increasingly underpinned by philosophical conviction about the function of pottery at a time when the position of the potter as an artist was beginning to be undermined by external factors. The depressed economic climate of the late 1920s and 1930s destabilized the market for highly priced artistic pots by makers such as Leach and Staite Murray, though Leach made individual pots throughout his life. Staite Murray was in Southern Rhodesia (modern Zimbabwe) when war broke out in 1939 (he did not return until 1957) and he never made another pot. This enabled Leach and his school quickly to eclipse his reputation and influence. In the following decades it was the 'necessary' and 'ethical' pot that came to dominate both the practice and the historiography of British studio pottery.

Note on provenance and dating of pots

All pots are from the collection of Gallery Oldham and were acquired through the Contemporary Art Society unless otherwise stated. Oldham Art Gallery received its first works from the CAS Pottery and Craft Fund in 1939. Pots were often exhibited for several years before they were distributed, so, though most of the pots in the collection are undated, the production date can in most cases be assumed to be considerably earlier than the acquisition date.

1. *Early Chinese Pottery and Porcelain*, exh. cat., Burlington Fine Arts Club, London, 1910, p. xvii.

2. Charles Marriott, *British Handicrafts*, London 1943, pp. 33–34.

3. Tanya Harrod, *The Crafts in Britain in the Twentieth Century*, New Haven and London 1999, pp. 30–42, 118–20.

4. William Staite Murray, 'Pottery from the artist's point of view', *Artwork*, 1, no. 4, May–August 1925, p. 205.

5. *Ibid.*, p. 202. See also Herbert Read, *The Meaning of Art*, London 1936, p. 41.

6. Herbert Read, 'Art and Decoration', *The Listener*, 7 May 1930, p. 805.

7. Bernard Rackham, 'Mr W.S. Murray's Flambé Stoneware', *The Studio*, 88, July–December 1924, p. 318.

8. *The Leach Pottery*, exh. cat., The Berkeley Galleries, London, June 1946.

9. Oliver Watson, *Bernard Leach: Potter and Artist*, 1997, p.101.

10. *Exhibition of Pottery by Shoji Hamada*, Paterson's Gallery. London, 1931.

11. *The Leach Pottery*, London 1946, as note 8.

12. Edmund de Waal, *Bernard Leach*, London 1997, p. 41.

13. The Hyman Kreitman Research Centre, Tate Britain, CAS Archive Minutes of Executive Committee Meeting, 7 February 1945 and 1 March 1945. Tate 9215.2.2.3.

14. Chairman's speech and Minutes of meeting 29 October 1947. Tate 9215.2.2.4.

86

Norah Braden
(1901–2001)

Vase
Stoneware with painted decoration
H: 14 cm
Mark: NB, incised
Acquired 1939

Norah Braden studied painting before arriving at the
St Ives Pottery in 1925. The principal of the Royal College of Art,
William Rothenstein, told Leach, "I am sending you a genius",
and Leach later described her as "the most sensitive" of his
pupils (in exh. cat. *The Leach Pottery*, The Berkeley Galleries,
London, June 1946). In 1928 Braden joined Pleydell-Bouverie at
Coleshill in Berkshire, leaving in 1936. She made very few pots
after this date.

The shape of this pot is East Asian in inspiration and
demonstrates Braden's natural instinct for decorating three-
dimensional form.

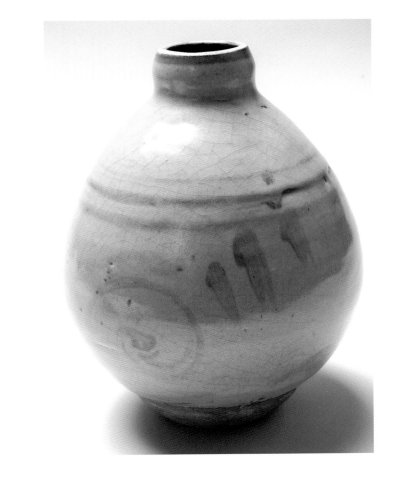

87

Norah Braden
(1901–2001)

Bowl
Stoneware with manganese glaze
H: 11.5 cm
Mark: NB, painted
Acquired 1943

The beauty of this elegantly thrown pot comes from the
depth and subtlety of the glaze, with its lustrous colours.

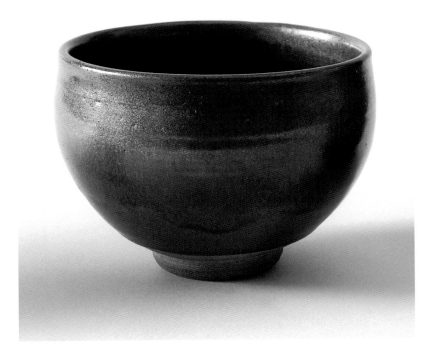

88

Michael Cardew
(1901–1983)

Jug

Earthenware, galena-glazed body with dark brown slip decoration
H: 22.8 cm
Mark: Winchcombe Pottery mark, impressed
Acquired 1943

Michael Cardew had come into contact with the traditional slipware of North Devon in his youth and was passionate about exploring this dying tradition. Galena glaze is finely ground lead ore. Bernard Leach and Shoji Hamada had pioneered the early recovery of slipware techniques, collecting and analysing thousands of sherds. Cardew was at Winchcombe from 1926 to 1939 and again from 1941 to 1942; it is likely that this jug was made in the first period.

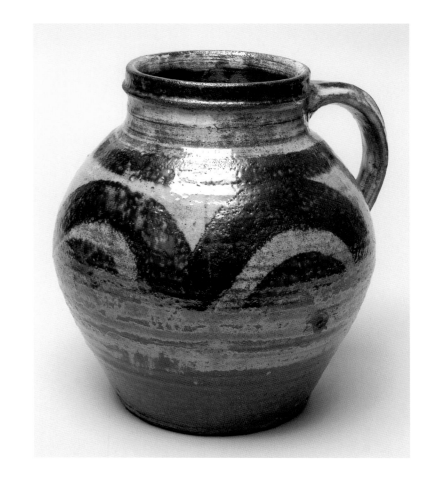

89

William Bower Dalton
(1868–1965)

Bowl

Stoneware, glazed, incised decoration
Diam: 19 cm
Mark: WBD monogram, incised
Acquired 1943

W.B.Dalton was a painter as well as a potter and believed that pottery should strive to be recognised as an art, on a par with the traditional 'fine arts'. This bowl faithfully reflects the qualities of Chinese wares of the Song dynasty that were so influential in the early part of the century – monochrome opaque glazes, smooth matt surface and sturdy simple forms.

90

Bernard Leach
(1887–1979)

Ewer

Stoneware, glazed
H: 4.5 cm
Mark: BL and St Ives mongram, impressed
Acquired 1950

English medieval pottery was an important influence on
Bernard Leach's early work, and he returned to traditional
English forms, like this ewer, throughout his life.

91

Bernard Leach
(1887–1979)

Mustard pot

Stoneware, glazed, with painted decoration on lid
H: 10 cm
Mark: BL and St Ives monogram, impressed
Purchased from The Little Gallery, Ellis St, London, 1936

This pot is a good example of the functional ware that was made at the
Leach pottery by Leach himself, and other makers, before production
was re-organized by David Leach in the late 1930s and the Standard
Ware range was launched. Though a modest piece, it reflects the vitality
of Leach's hand, with its pleasing shape, glaze effects on the body and
spontaneous, and rather irregular, brushwork on the lid.

The Little Gallery was established in 1928. In 1935 it had shown
Japanese wares brought back by Leach and was one of the first outlets
in which he offered the Standard Ware range in 1938.

92

Bernard Leach
(1887–1979)

Tile

Glazed stoneware
H: 10 cm
Bolton Museum and Art Gallery

Leach began to produce decorative tiles in the late
1920s in an effort to stave off bankruptcy. The great
Kano earthquake in Japan in 1923 had wiped out the
major market for his pots and the British art market was
undermined by the worsening economic climate
following the General Strike of 1926. The tiles could be
produced easily at the pottery (later, blanks were bought
in) and provided an ideal 'canvas' for Leach's lively
painting. They were decorated with stylized motifs that
clearly combine Eastern and Western decorative
traditions. Inevitable distortions in the firing process
simply added to the homespun appeal of the tiles,
described by *The Times* as having "bread and butter"
instead of "cake" qualities.

93

Martin Brothers

Stoneware, deeply gadrooned with grey and
brown glaze
H: 26.5 cm
Marks: 7-1902 Martin Bros London Southall, incised
Mary Edmonds Bequest through the National Art
Collections Fund

The Martin Brothers, Robert (1843–1924), Charles
(1846–1910), Walter (1857–1912) and Edwin
(1860–1915), are generally considered to be the first
studio potters in Britain, as they controlled every aspect
of production themselves. Their early salt-glazed wares
were decorated with Renaissance-style or Japanese-
inspired ornament but Edwin had been experimenting
with more abstract, organic forms in the 1890s. This style
became dominant following their visit to the 1900 Paris
Exposition Universelle, where they were introduced to the
stylized quality of Art Nouveau ornament. The organic
naturalistic forms of pots such as this one were often
startlingly abstract and are generally regarded as their
finest achievement.

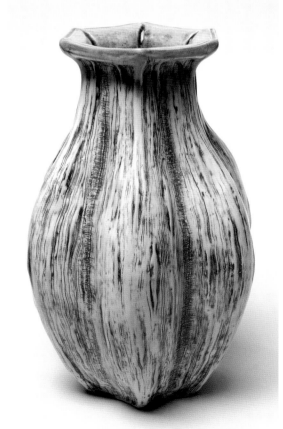

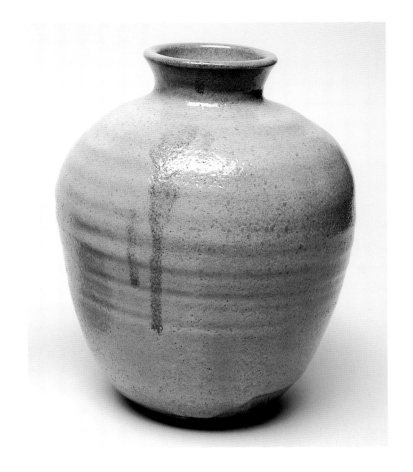

94

William Staite Murray
(1881–1962)

Vase

Stoneware, glazed with a purple splash
H: 23.6 cm
Mark: M in pentagon, impressed
Acquired 1943

In 1927 Edward Marsh gave the Contemporary Art Society a grey-blue jar by Staite Murray, its first acquisition of studio pottery, which was, presumably, accepted as a work of contemporary art. The pot was subsequently transferred in July 1929 to the recently created Pottery and Craft Fund. A very similar pot in the Victoria and Albert Museum was acquired in 1927, which suggests that the Oldham pot is similar in date, and, though it was not presented to Oldham Art Gallery until 1943, that this may well be that first pot acquired by the Contemporary Art Society.

95

William Staite Murray
(1881–1962)

Vase

Stoneware with crackle glaze and painted decoration
H: 26.5 cm
Mark: M in pentagon, impressed

In the mid 1920s Staite Murray began to move away from his Song inspiration. He was shifting from decorating his pots with glazes to exploring the possibilities of brushwork and incised decoration. Murray, trained as a painter, increasingly painted his pots with both figurative and lyrical abstract brushwork. This pot was purchased by the Oldham Gallery directly from Staite Murray in 1937.

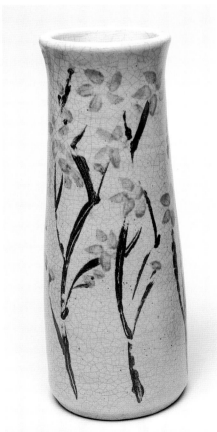

96

William Staite Murray
(1881–1962)

Bowl

Stoneware, glazed
Diam: 17.7 cm
Mark: M in pentagon, impressed
Acquired 1939

In his seminal article 'Pottery from the Artist's point of view' Staite Murray commented that the sensibility of the artist "recognises the timbre of a glaze as it would the quality of bronze or paint" (*Artwork*, 1, no. 4, May–August 1925, p. 205). This pot, so simple in form, demonstrates the exquisite possibilities of pure glaze that were suggested to potters by the discovery of Chinese Song dynasty wares.

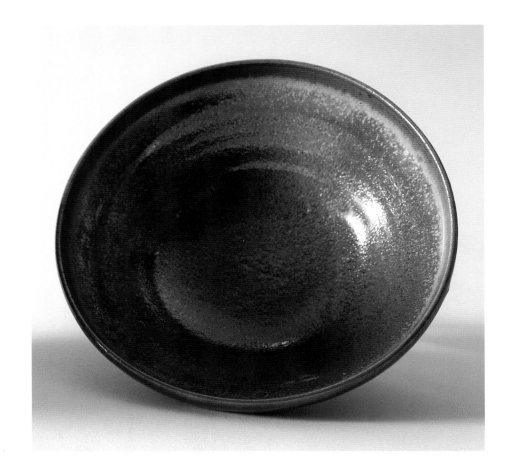

97

Katherine Pleydell-Bouverie
(1895–1985)

Vase

Stoneware, glazed with bands of trickled slip
H: 26 cm
Mark: KPB monogram, impressed
Acquired 1943

Pleydell-Bouverie wrote in 1928: "I want my pots to make people think, not of the Chinese, but of things like pebbles and shells and bird's eggs and stones over which moss grows". The low tones of the glaze of this pot are typical of her work. She expected her very organic and abstractly beautiful pots to be functional as well as decorative and noted that "Flowers stand out of them more pleasantly, it seems to me" (*Katherine Pleydell-Bouverie, A Potter's Life 1895-1985*, exh. cat., Crafts Council/Crafts Study Centre, London, 1986).

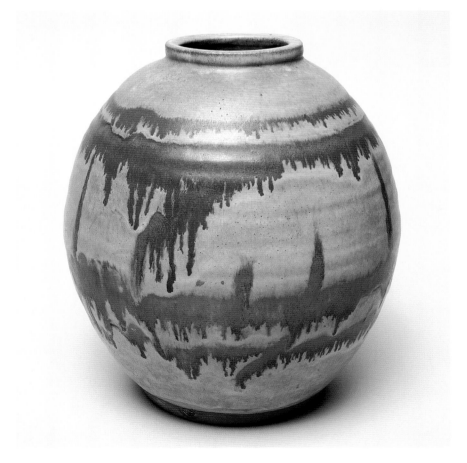

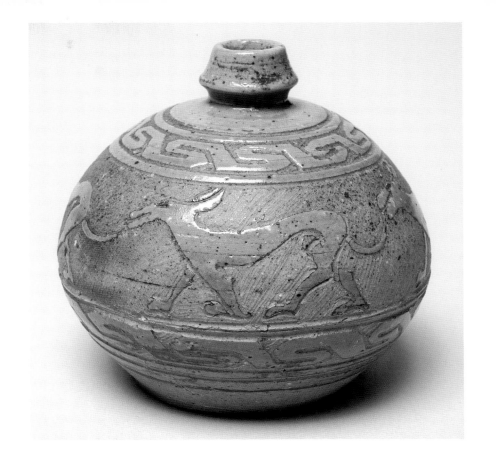

98

Katherine Pleydell-Bouverie
(1895–1985)

Bottle

Stoneware, with sgraffito decoration through glaze

H: 7.5 cm

Marks: COLE and KPB, impressed

Mary Edmonds Bequest through the National Art Collections Fund

The dogs that decorate this little bottle were created by cutting into the clay body, a technique derived from T'zu Chou wares from the Song dynasty. Figurative decoration like this is not typical of Pleydell-Bouverie's output. She tended not to borrow so literally from Chinese techniques, though there are other examples of her work with similar decoration in the Milner-White Collection at York and at the Crafts Study Centre in Surrey.

99

Marjorie Terry

Bowl

Stoneware, glazed

H: 12 cm

Mark: Terry, incised

Acquired 1942

Terry trained at Royal College of Art under Staite Murray. Murray gave little direct technical instruction but did inspire his pupils to follow their artistic and expressive inclinations. This bowl combines vigorous brushwork with subtle effects of colour as bright turquoise evolves into more muted areas of mottled green and brown glaze.

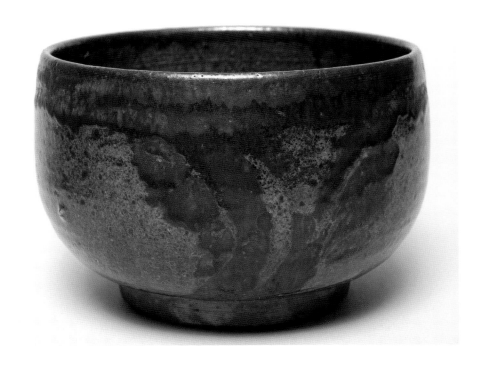

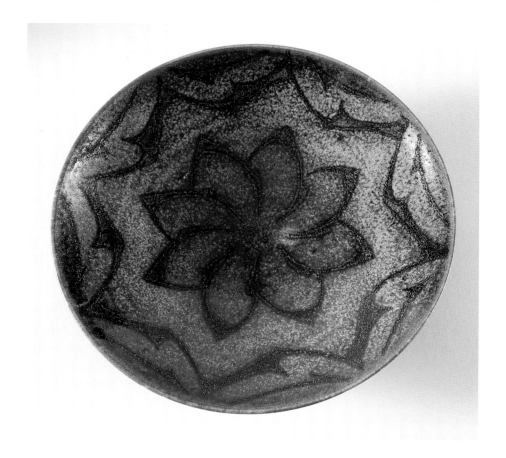

100

Charles and Nell Vyse
(1882–1971; 1892–1967)

Bowl

Stoneware with elm ash glaze
Diam: 18.5 cm
Mark: Vyse 1936, incised
Acquired 1942

Leach described the work of the Vyses in 1929 as "really without life but technically wonderful" (Edmund de Waal, *Bernard Leach*, 1997, p. 37). Despite ambivalence to the artistic merit of their work in studio pottery circles the Contemporary Art Society bought large numbers of their pots and distributed them to public galleries. Oldham received four examples of their work

101

Robert Washington
(1913–1997)

Vase

Stoneware, glazed
H: 54 cm
Acquired 1942

Washington left the Royal College of Art in 1938; pots from the early period immediately following his departure are relatively rare. He once stated his desire to "preserve the qualities of lip, neck, shoulders, breast, belly, foot – all those changes of plane which we see so clearly and yet so subtly in the natural form". His large vases are reminiscent of the monumental anthropomorphic pots of Staite Murray, but retain their own identity, especially in the brushwork. Washington described himself as a painter working in his chosen medium, believing that the decoration on his pots was "an enrichment which is used to make the pot more like itself". The strong throwing lines in this pot are typical of Washington, who was interested in creating form in the two-dimensional profile of the pots.

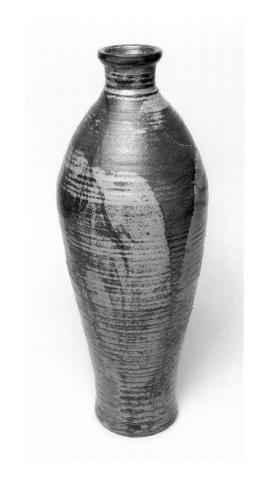

British Painters and Surrealism

Wadsworth Armstrong

Burra Hillier

Penrose Newton

Collins

Trevelyan

Jennings

Banting

British Painters and Surrealism

by David Morris

Surrealism arrived comparatively late in Britain. Although individual artists had already come under Surrealist influence, it was not until 1936, and the mounting of the International Surrealist Exhibition in London, that a group was officially formed in Britain; this was twelve years after the poet André Breton had issued the First Surrealist Manifesto in Paris in 1924. In the troubled aftermath of the First World War, Breton and the Surrealists thought that dreams and other altered states of consciousness would be the instruments for the creative liberation of poets and artists: "I believe in the future resolution of those two states, so contradictory in appearance – dream and reality – into a kind of absolute reality, of surreality, if one may call it so".[1]

At its origins, then, Surrealism should properly be thought of as a revolutionary way of perceiving the world and, since the movement had adopted a Marxist political position from the mid 1920s, as having aspirations fundamentally to change society; it was not just a style of painting. Breton argued that the artists most influential on visual Surrealism were Picasso and Giorgio de Chirico.[2] The early responses of British painters to the Surrealist project were variable and individual. From the mid 1920s Paul Nash, Edward Wadsworth, Tristram Hillier, and John Armstrong became interested in the enigmatic and dream-like paintings of Giorgio de Chirico. By the early 1930s they had developed, partly from De Chirico's example, an interest in using memory, and objects or places with particular associations, in the process of formulating subjects for painting. Of these artists, only Nash was included in the International Surrealist Exhibition in 1936 and became a member of the English Surrealist group.[3]

John Armstrong was largely self-taught as an artist, rarely went to France and had no direct contact with any French Surrealist during the 1920s. However, through the exhibitions he saw in London and the art magazines he read, he developed a style that is reminiscent of De Chirico, based on shifts of scale, spatial discontinuities and a meticulous attention to detail – as in his early Still Life (cat 112).[4]

In contrast to Armstrong, Edward Wadsworth spent much of the 1920s living in France and was well known amongst artists, critics and collectors on the Continent, securing a one-man show in Paris in 1927. Between 1926 and 1929 he painted a series of marine still lifes that are strongly influenced by De Chirico in mood and technique. In the early 1930s Wadsworth made paintings with hard-edged but fluid forms, inspired by "the disciplined lyricism of the machine", but in 1934 he had returned to representational painting and marine subjects, again drawing on the alienated dream images of De Chirico and the Surrealists. He painted the emotionally charged Imaginary Harbour II (cat 102) in the late autumn of 1934, after a period of recuperation in Marseilles following a serious road accident in May, in which he had knocked down and killed a man when driving his Rolls Royce.[5]

Although Wadsworth did not exhibit at the London International Surrealist Exhibition in 1936, many contemporary critics associated him with Surrealism, and his marine still lifes of the 1930s and 1940s brought him as close as he ever came to being categorized with the movement. *The Perspective of Idleness II* (cat 104) was painted in 1942; a first version of the subject, with a slightly different arrangement of pipes, had been painted late in 1936. As well as relating to De Chirico, these paintings have some affinity with the work of the leading Belgian Surrealist René Magritte. Wadsworth's two paintings on this theme may comprise his quizzical reflections on the arrival and uncertain progress of international Surrealism in England, from his own perspective of detached non-participation rather than 'idleness'. Both paintings feature a prominent and brightly coloured anaesthetist's pipe, with its associations of drug-induced unconsciousness and troubled dreams.[6]

The International Surrealist Exhibition that opened in London in 1936 was the largest show of Surrealist art anywhere in the world up to that time. There were four hundred exhibits by fifty-four artists from fourteen nations. The painter and collector Roland Penrose and the poet David Gascoyne planned the exhibition after they had met for the first time in 1935 in Paris, and decided to bring the "revelation" of Surrealism to England. Penrose was already well connected in Surrealist circles through his friendship with Max Ernst and contacts with Man Ray, André Breton and Paul Eluard. Gascoyne was in Paris researching his ground-breaking book, *A Short Survey of Surrealism*, which was published later in the same year.[7] The exhibition excited phenomenal interest, provoking controversy in the press and debate amongst artists and public alike.[8]

In 1937 Penrose met and was captivated by the American photographer Lee Miller. They became lovers and Miller became the inspiration for many of Penrose's new works. They eventually married when she became pregnant in 1947. In the same year Penrose painted a double portrait called *Surrealist Composition* (cat 105) that marked the marriage but also celebrated their continued independence of spirit.[9]

Edward Burra was invited to show in the exhibition in 1936, as he was one of the first British artists to paint fantastic dream imagery inspired by Surrealism. Burra's reading of avant-garde and Surrealist periodicals influenced his work after about 1930, and he had also encountered Surrealism at first hand, on a trip to the south of France with his close friend Paul Nash in 1930. However, although Burra joined the English Surrealist group and sometimes exhibited with them, he retained his independent outlook. It was in his paintings of grotesquely transformed female figures in the early 1930s that Burra came closest to the concerns of Surrealism. In *Bird Women (Duennas)* (cat 103) Burra took Goya's respectable Spanish nannies and, analogously to artists like Joan Miró and Max Ernst, satirized them by turning them into bizarre Surrealist *personnages*. Furthermore, many of Burra's paintings of this period, such as *News of the World* (cat 110), can be seen as a subversion of the society portrait tradition in English art.[10]

John Banting's work was also often bitingly satirical. From 1922 he visited Paris regularly and lived there during 1930, when he met many of the Surrealists, including Breton, Duchamp and Giacometti. In his series of blueprints, *A Blue Book of Conversation*, on which he worked from the early 1930s and which he published as a book in 1946, Banting denounced the social hypocrisy of the upper classes in Britain. These satirical attacks were counterbalanced in Banting's production by a series of paintings and prints with the composite motif of the *Goat Man* (cat 109), which had for him an energizing and positive meaning relating to his passion for the creative freedom of jazz improvisation.[11] Banting combined Surrealism with an active commitment to the Stalinist wing of the Communist Party, and he continued this political stance into the 1950s. Many artists, writers and intellectuals were attracted to the revolutionary political ideas and direct actions of Surrealism, particularly after the outbreak of the Spanish Civil War in 1936. Humphrey Jennings and Julian Trevelyan, who were both more politically libertarian than Banting, worked with the Mass Observation project in 1937–38, and exemplified a different strand of the

English Surrealist Group's engagement with social questions. The public impact of the Group's political activities became increasingly marginal during the Second World War.

Although better known as a documentary film-maker of wartime classics like *Listen to Britain* (1942), Humphrey Jennings regarded himself as primarily a painter, as well as a poet and photographer. In the early 1930s his poetry and translations of texts by Breton, Eluard and Dalí contributed to a greater appreciation of Surrealism in Britain. He helped to organize the International Surrealist Exhibition in London in 1936, and later co-edited the Surrealist *London Bulletin* with E.L.T. Mesens.[12] The keys to understanding Jennings' work lie in his fascination for Britain's role as the first industrial power and his particular idea of the image. His research on the impact of machines on the human imagination during the Industrial Revolution led to his accumulation of a vast archive of material called *Pandemonium*, and to his becoming a founder member of Mass Observation in 1937, along with the anthropologist Tom Harrison and the leftist poet Charles Madge. Jennings's participation in Mass Observation in 1936–37 helped to give what was essentially a project of social research a Surrealist edge.[13]

After the Second World War, Jennings returned to painting and produced some of his strongest work, such as *Listen to Britain* (cat 108). Here Jennings reworked in paint a key image from his wartime film to create an example of what he called "mutations in the subject". Since the early 1930s, he had been seeking techniques by means of which his paintings could reflect the contemporary sense of a cosmos in flux, by developing "a new solidity as firm as Cubism, but fluid". In his later paintings, with their post-Cubist energy and vivid colour, Jennings felt his search for a viable new technique was approaching resolution. However, the patriotic mythologizing of much of this later work took Jennings away from the preoccupations of the Surrealists, and in 1947 he was excluded from the group.[14]

Jennings and his fellow contributor to Mass Observation, Julian Trevelyan, had known each other since meeting in the early 1930s at Cambridge University. In 1931 Trevelyan studied in Paris at Atelier 17 with S.W. Hayter, returning to England in 1935. Trevelyan's main concern in his Surrealist work was the construction of a new collective myth of the city, a theme that had fascinated him since childhood. He described how he "had invented a sort of mythology of cities, of fragile structures carrying here and there a few waif-like inhabitants". He produced ethereal images of urban structures and spaces, linked by a network of energetic lines and inhabited by biomorphic shapes.[15] Trevelyan was engaged by Mass Observation in 1937–38 to paint scenes in Worktown (Bolton); instead, he developed the collage technique he had derived from the Surrealists, using torn shreds of newspapers (symbols of community relationships and communication) to depict buildings and the landscape. In *Bolton Mills* (cat 107) he attempted to evolve his personal myth of the city into one closer to the reality of the lives of the working-class inhabitants of urban Britain.[16]

While Penrose, Jennings, Trevelyan, Banting and, to some extent, Burra operated at the centre of British Surrealism, Cecil Collins and Tristram Hillier, like Armstrong and Wadsworth, were on the fringes of the movement. Collins was invited to contribute to the International Surrealist Exhibition in 1936, and he agreed. However, one of the paintings he exhibited had clear references to Christian imagery and texts, and was anathema to the orthodox Surrealists from France. Collins's link with the group was severed, and he for his part was equally keen to distance himself from the Surrealists and to pursue his distinctive metaphysical painting, attempting to re-create pictorially what he perceived to be the lost paradise of humanity's spiritual unity. In 1942 Collins began writing his most famous essay, *The Vision of the Fool* (published in 1947), and painted a series of images related to the text including *Thy Thoughts O Life* (cat 106). Collins's vision of the Fool was a singular blend of lightness and dignity that satirized twentieth-century materialism and war.[17]

Tristram Hillier was another artist whose work had been loosely associated with Surrealism in the early 1930s, although in his essay for the Unit One book in 1934 he rejected what he saw as the exaggerations of Salvador Dalí. Hillier did not exhibit in the 1936 Surrealist Exhibition, and soon after his style changed to a more traditional figurative manner, influenced by his fascination with Flemish and Italian fifteenth-century art. While this new approach was a technical retreat from his earlier Surrealist-inspired work, he was at the same time seeking to devise another way of communicating his sense of the mystery of objects in the world. Hillier painted *The Argument* (cat 111), a rare figure subject, in this new style in 1943. It is an enigmatic work, where Hillier teases the viewer with the promise of a conventional narrative, but then subverts that expectation by means of the painting's many ambiguous and dream-like details.[18]

In his later work, John Armstrong, too, sometimes dealt with overtly religious or mystical themes that would have been anathema to orthodox Surrealists. Armstrong was the third son of an Anglican clergyman and, although he did not practise it, religion remained with him in an unorthodox way all his life. He was fascinated by altered states of consciousness achieved through prayer and meditation, an area of human experience he saw as related to his earlier interest in dream imagery. He thought of the art of painting as "a direct attack in the spiritual world". He made *A Vision of St Teresa* (cat 114) in 1953.[19]

Referring to the work of Algernon Newton in the context of a discussion about British artists and Surrealism may seem out of place. Newton's pictorial language and technique were developed from his study of the Old Masters, particularly Canaletto, in the National Gallery between 1919 and 1923, and were therefore securely rooted in the established traditions of painting that Surrealism set out to satirize and overturn. Nevertheless, Newton once wrote about how, when seeking subjects to paint, he would deliberately lose himself, as if in a daydream, when walking in London; and how he drew upon memory and imagination to invest his paintings with their trance-like vision and a sense of a presence beyond the ordinary. In *House by a London Canal* (cat 113), Newton shows that he may also have absorbed some alternative ways of constructing images from the work of Surrealist painters, such as Magritte or Humphrey Jennings. In the way that the grey smoke from the factory chimney metamorphoses itself into a bright blue opening in a dark sky – industry transformed into nature – Newton displayed a characteristically understated response to the challenge of Surrealism and meditated on the oddness and wonder to be found in the everyday.[20]

1. Breton and the small group of like-minded poets and artists he had gathered around him perceived a deep crisis in Western culture in the aftermath of the First World War. Starting in Zurich in 1916, various Dada groups in European cities (but not in London) and in New York had launched a sustained attack on existing art and society; the Surrealists responded with a call for a complete revolution of beliefs and ideals, to be achieved by breaking the chains of rationalism. Breton concluded that poetry, art and life could only be free and renew themselves by contacting forbidden areas of the mind – the Unconscious – and disclosing a whole network of hidden relationships. While Sigmund Freud wished to understand the Unconscious mind in order to cure psychic disorders, Breton and the Surrealists sought to adapt his theories to approach the threshold of liberty in every field of human activity.
André Breton, *First Surrealist Manifesto*, 1924. For further information on Surrealism, see Dawn Ades, David Sylvester and Elizabeth Cowling, *Dada and Surrealism Reviewed*, exh. cat., The Hayward Gallery, London, 1978; Maurice Nadeau, *The History of Surrealism*, Cambridge, Mass., 1978; Robert Hughes, 'The Threshold of Liberty', in *The Shock of the New: Art and the Century of Change*, London 1980, pp. 212–68.

2. Since it was in origin a literary movement, the way in which Surrealism might be expressed visually was a source of fierce and continued debate among its adherents. In a footnote to the *Manifesto* in 1924 Breton suggested that Pablo Picasso, Paul Klee, Marcel Duchamp, Francis Picabia and Giorgio de Chirico (at least in his paintings before the 1920s) were the leading living artists whose work was compatible with Surrealism. The major artists associated with the movement itself developed two distinct approaches to making Surrealist visual images. The first involved the use of various automatic techniques that sought to free the artist from the constraints imposed by the conscious mind (André Masson and Max Ernst). The second was an illusionistic dream-like style of painting, deriving from De Chirico's hallucinatory cityscapes and interiors, where strange objects were unexpectedly juxtaposed (Ernst, René Magritte and Salvador Dalí).

3. See Charles Harrison, *English Art and Modernism 1900–1939*, New Haven and London 1994, pp. 231–53.

4. In his essay for the Unit One publication, where he wrote about the development of his work, Armstrong referred to the period of his career when he made *Still Life* (cat 112): "I ... began to make a fence for myself with a picture-frame and enclose it still further in an arbitrary room ... I saw that it was possible to make a form which would at once dominate and accept its surroundings, which would submit to my limitations and enlarge and quicken them into space outside".
Herbert Read (ed.), *Unit One*, 1934, p. 39. For further information on Armstrong, see *John Armstrong 1893–1973*, exh. cat., Royal Academy of Arts, London, 1975.

5. Herbert Read (ed.), *Unit One*, 1934, p. 98. Wadsworth's abstract paintings were related to works by French Purist artists such as Léger and Ozenfant. For further information on Wadsworth see Jeremy Lewison (ed.), *A Genius of Industrial England: Edward Wadsworth 1889–1949*, exh. cat., Cartwright Hall, Bradford, 1989–90; Barbara Wadsworth, *Edward Wadsworth: A Painter's Life*, Salisbury 1989.

6. The titles of the paintings are enigmatic and both works have a pictorial structure new for Wadsworth, using a horizontal timber beam at the top of the image from which various pipes are suspended. Timber beams and smokers' pipes were features of several paintings by Magritte in the late 1920s and 1930s, including one of his most famous works, *The Betrayal of Images*, painted in 1928–29.

7. In London, the organizing committee consisted of Penrose, Gascoyne, Hugh Sykes Davies, Humphrey Jennings, Edward McKnight Kauffer, Rupert Lee, Henry Moore, Paul Nash and Herbert Read. They enlisted the help of André Breton, Paul Eluard and Man Ray to select the bulk of the exhibition, which comprised work by French artists; E.L.T. Mesens selected works from Belgium, including several by Magritte; Dalí oversaw the Spanish selection; and Penrose, Rea, and Nash selected those British artists who they thought sufficiently Surrealist to be included.

8. Penrose's support for the movement continued with his purchase of the London Gallery in Cork Street in 1938. Penrose became a director, and with the Belgian Surrealist E.L.T. Mesens as manager, the gallery became the centre for the Surrealist movement in Britain, publishing the journal *London Bulletin* between 1938 and 1940. For further information on Surrealism in Britain, see Michel Remy, 'Surrealism's vertiginous descent on Britain', in *Surrealism in Britain in the Thirties*, exh. cat., Leeds City Art Gallery, 1986, pp. 19–55; Michel Remy, *Surrealism in Britain*, London 1999; Harrison 1994 (see note 3), pp. 294–331. Two key texts that introduced Surrealism to Britain are David Gascoyne, *A Short Survey of Surrealism*, London 1935, and Herbert Read (ed.), *Surrealism*, London 1936.

9. For further information on Penrose, see *Roland Penrose, Lee Miller: The Surrealist and the Photographer*, Scottish National Gallery of Modern Art, 2001; Roland Penrose, *Scrap Book 1900–1981*, 1981; Antony Penrose, *Roland Penrose: The Friendly Surrealist*, 2001.

10. For further information on Burra see Andrew Causey, *Edward Burra: Complete Catalogue*, 1985; *Edward Burra*, exh. cat., Hayward Gallery, 1985; William Chappell (ed.), *Well, dearie!: The Letters of Edward Burra*, 1985; William Chappell (ed.), *Edward Burra: A Painter remembered by his Friends*, 1982.

11. For further information on Banting see John Banting, *The Blue Book of Conversation*, 1946; Julian Trevelyan, 'John Banting – an English Surrealist', *Painter and Sculptor*, 1, 2, summer 1958, pp. 6–9.

12. For further information on Jennings see Mary-Lou Jennings (ed.), *Humphrey Jennings: Film-Maker, Painter, Poet*, British Film Institute in association with Riverside Studios, 1982.

13. "How little we know of our next-door neighbour and his habits; how little we know of ourselves. Of conditions of life and thought in another class or another district, our ignorance is complete. The anthropology of ourselves is still only a dream." From Tom Harrison and Charles Madge, *Mass-Observation*, London 1937.

14. Quoted in Jennings 1982 (see note 12), p. 48.

15. Julian Trevelyan, *Indigo Days*, Merston 1957, p. 66.

16. For further information on Trevelyan see Julian Trevelyan, *Indigo Days*, 1957; *Julian Trevelyan: A First Retrospective*, exh. cat., Watermans Arts Centre, Brentford, 1985.

17. For further information on Collins see *Cecil Collins*, exh. cat., Tate Gallery, London, 1989; *The Vision of the Fool: Early Drawings by Cecil Collins*, exh. cat., Anthony d'Offay Gallery, London, March–April 1991.

18. Hillier developed his hybrid style from a synthesis of Surrealism and Cubism when he was living in France between 1927 and 1933. He was a member of Unit One in 1934, and, while his exhibited works included an eerie and proto-surreal image of electrical pylons on a deserted beach, in his essay for the book he also criticized the approach of Dalí: "My aim is to build up a composition in a representative manner, assembling objects which have a mutual plastic complement and a similar evocative nature irrespective of their individual functions It appears to me a very natural form of symbolism and unlike Monsieur Dali, I have no wish to shock people's sensibilities by juxtaposing the most unlikely objects in an improbable landscape."
Herbert Read (ed.), *Unit One*, 1934, p. 69. For further information on Hillier see *A Timeless Journey: Tristram Hillier R.A. 1905–1983*, exh. cat., Bradford Art Galleries and Museums, 1983.

19. Quoted in Mark Glazebrook, 'Introduction', *John Armstrong 1893–1973*, exh. cat., Royal Academy of Arts, London, 1975, p. 1.

20. For further information on Newton see *Algernon Newton R.A. 1880–1968*, exh. cat., Graves Art Gallery, Sheffield, 1980.

102

Edward Wadsworth
(1889–1949)

Imaginary Harbour II , 1934
Tempera on linen, laid on board
57.1 x 81.3 cm

This painting was made in the late autumn of 1934, the year in which Wadsworth returned to representational painting and marine subjects after a three-year period working on biomorphic abstract images. His adoption here of a pointillist style perhaps referred nostalgically to Seurat's harbour scenes of the 1880s, but also served to break up the evenness of the tempera surface, and emphasized that this was a work of the imagination rather than a transcription of a real scene.

103

Edward Burra
(1905–1976)

Bird Women (Duennas), 1932
Watercolour and gouache over pencil and pen and ink on paper
75.1 x 95.2 cm

This work is one of a series of pictures Burra made in the early 1930s featuring female bird-figures or duennas. A duenna is a Spanish word for a nanny or mother substitute who was traditionally middle-aged or elderly and very respectable. Burra enjoyed subverting this ideal of genteel respectability. He was aware of the Surrealists' interest in the metamorphosis of human to bird or animal, particularly Max Ernst's female bird figures, and of the long ancestry of such imagery, reaching back to Bosch and the medieval bestiary.

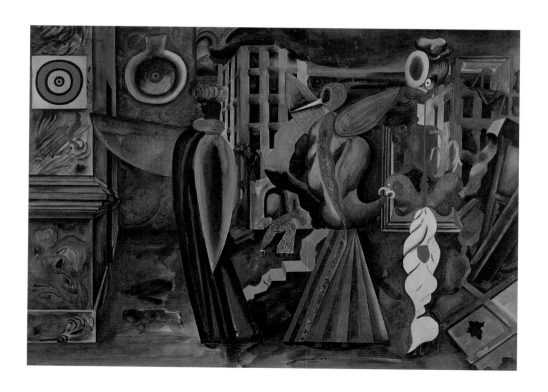

104

Edward Wadsworth
(1889–1949)

The Perspective of Idleness II, 1942
Tempera on linen, laid on board
76 x 58 cm

This painting is an example of what has become known
as Wadsworth's 'magic realism' – a marine still life
influenced by a sense of the uncanny inherent in the
grouping of disparate objects. Wadsworth has depicted,
in hallucinatory detail, various sorts of pipe seen against
the brightly lit background of a calm sea and cloudless
blue sky. The sense of potential movement in these
objects, in an otherwise eerily still scene, is accentuated
by the vibrant colour of an anaesthetist's tube, which
seems to oscillate gently between the upper and lower
sections of the painting.

105

Roland Penrose
(1900–1984)

Surrealist Composition, 1947–49
Oil on canvas
48.3 x 59.7 cm

The figure on the right in the painting is the artist himself,
with his arm placed around the shoulder of a woman,
Lee Miller, the surrealist photographer and photojournalist
who became his lover in 1937 and his wife in 1947. In
the same year that he finished and exhibited this picture,
Penrose had secured the loan from New York of
Picasso's famous painting *Les Demoiselles d'Avignon* for
the second exhibition at the Institute of Contemporary
Arts in London, *40,000 Years of Modern Art*. The heads in
Picasso's painting, based upon African tribal masks, may
have influenced Penrose in his portrayal of himself in
Surrealist Composition. Lee Miller's head is painted as
one huge eye, with a brilliant halo of light for her hair, an
allusion to her life as a photographer.

Cecil Collins
(1908–1989)

"Thy Thoughts O Life", 1942
Watercolour and ink on paper
38 x 55.5 cm

In 1942 Collins began work on his essay *The Vision of the Fool*, and the imagery in this painting – the sea, an island, the heart with a key, the shooting star illuminating the sky – is closely related to Collins's central concerns in this important text. It is one example of the Fool's utopian vision in the midst of wartime destruction. The work has elements of Collins's view of All Fools' Day: "At night there should be fireworks, the night sky strewn with holy signs of divine fun written in streams of fire ... that light up the dancing of all the Fools". It also recalls his vision of the re-birth of poetic imagination: "The hour of humility is the victory of poetic consciousness in life. It can be born when the hard crust of the habitual reality of modern society is melted, and its materialistic factuality becomes a great emptiness. Then can the world's horizon widen with the signs of the new time." The "hunger of the human heart", was, for Collins, the key to spiritual rebirth (Cecil Collins, *The Vision of the Fool*, 1947).

Julian Trevelyan
(1910–1988)

Bolton Mills, 1938
Collage on paper
38.7 x 56.5 cm

During his period of involvement with Mass Observation in 1937–38, Trevelyan often worked in Bolton, which was known as 'Worktown' in Mass Observation publications. Trevelyan wrote later in his autobiography: "At this time I was making collages; I carried a large suitcase full of newspapers, copies of *Picture Post*, seed catalogues, old bills, coloured papers and other scraps, together with a pair of scissors, a pot of gum and a bottle of Indian ink. I was applying the collage techniques I had learnt from the Surrealists to the thing seen, and I now tore up pictures of the Coronation crowds to make the cobblestones of Bolton" (Julian Trevelyan, *Indigo Days*, 1957).

108

Humphrey Jennings
(1907–1950)

Listen to Britain, c. 1949
Oil on canvas
76.2 x 101.5 cm

When Humphrey Jennings returned to painting after the
Second World War, he sometimes re-used images taken
from his wartime films and transformed them in paint to
create what he called "mutations in the subject". This
painting is based on a photograph taken during the
production of Jennings's film *Listen to Britain*, made in
1942. The original photograph of an audience in a
workers' canteen was probably taken during the filming
of a Flanagan and Allen concert in Blackpool.

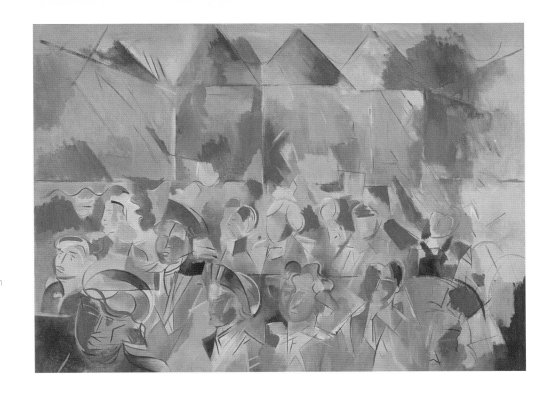

109

John Banting
(1909–1972)

Goat Man, c. 1935
Oil on canvas
76.2 x 101.5 cm

Banting's friend and fellow Surrealist Julian Trevelyan
remembered him in the 1930s as "a wild creature at this
time, dancing in nightclubs all night". Trevelyan also
wrote about the imagery of Banting's works about music:
"He never spoke to me about their significance, but I
know that they were all derived from what he called guitar
faces He was mad about jazz, and the idea behind
guitar faces was of someone playing himself" (Letter in
Tate Gallery files, dated 7 December 1974).

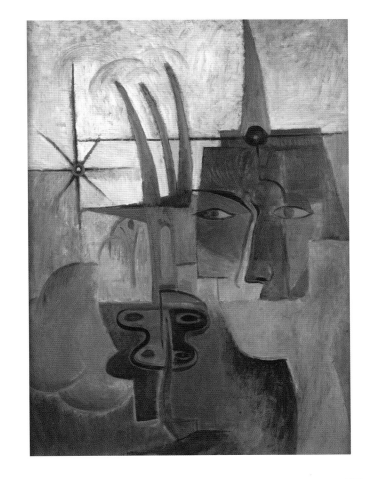

110

Edward Burra
(1905–1976)

News of the World, 1933–34
Watercolour and gouache over pencil and
pen and ink on paper
78.6 x 54.6 cm

Burra travelled extensively at the time that he was
painting this watercolour. The subjects of travel and
sexuality are alluded to in the jungle with its voyeuristic
faces, the desert hills with a lunar eclipse beyond, the
Navy Cut cigarette packet, and the bicycle with its
collection of fecund exotic fruits. The central red-clad
figure is sexually ambiguous, wearing high-heeled shoes
but also smoking a pipe. The truncated newspaper
masthead offers Burra's gently satirical commentary on
the ways of the world – *News of the Wo*[e]".

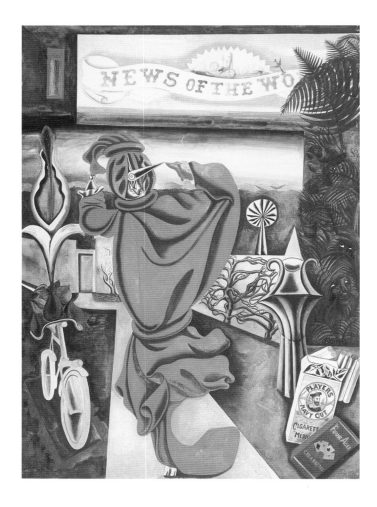

111

Tristram Hillier
(1905–1983)

The Argument, 1943
Oil on panel
26.7 x 40.6 cm

On a frosty winter's day, a man confronts an older man
and a younger woman on a country road. Hillier's three
figures, his apparently realistic style of representation,
and his title for the painting invite the viewer to construct
a plausible narrative for the action; the artist offers some
visual clues but ultimately the meaning of the painting
remains enigmatic. The ambiguous details of the image
constitute a significant development of what Hillier, in the
1930s, called his "very natural form of symbolism".

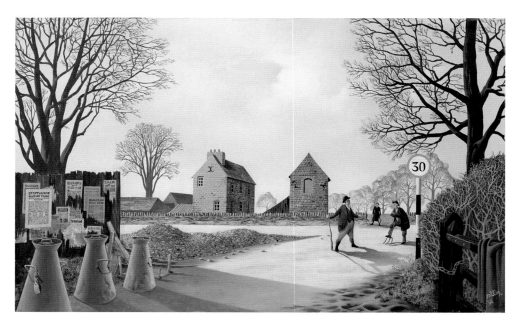

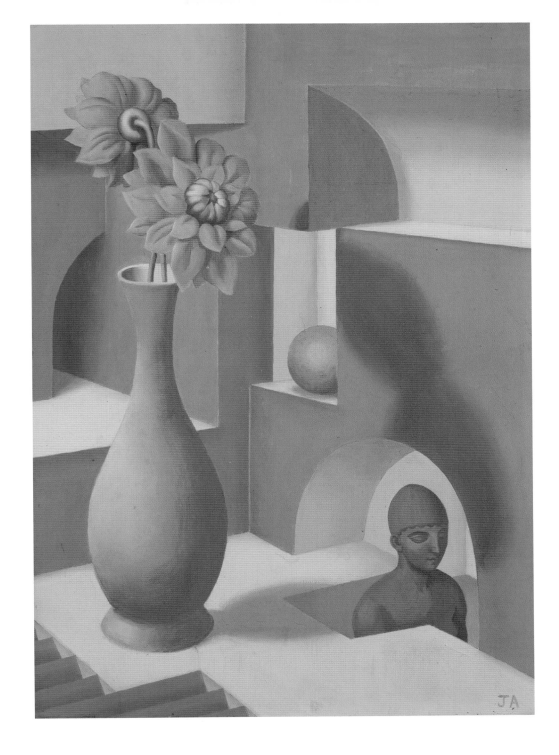

112

John Armstrong
(1893–1973)

Still Life, c. 1925–28
Oil on board
91.5 x 76 cm

Still Life displays the shifts of scale, spatial incongruities and attention to detail that characterize John Armstrong's early work. In the mid 1920s, Armstrong was working mainly as a theatrical designer and interior decorator, and his easel paintings often explored the interaction between two and three dimensions that was involved in decorating architectural spaces.

113

Algernon Newton
(1880–1968)

House by a London Canal, 1945
Oil on canvas
50.8 x 61 cm

From the mid 1920s, Algernon Newton was drawn to
depict melancholy scenes of urban dereliction and
decay in London. He frequented and painted the
neglected, run-down inner suburbs of the city, especially
the deserted waterways and disused industrial buildings
along the once busy Regent's Canal in Camden Town
and Kentish Town.

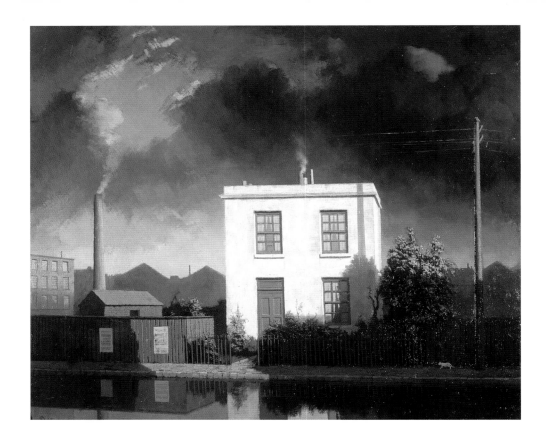

114

John Armstrong
(1893–1973)

A Vision of St Teresa, 1953
Oil on canvas
91.5 x 76 cm

The Interior Castle, one of the mystical books written by
the Spanish Carmelite nun St Teresa of Avila
(1515–1582), was the inspiration for *A Vision of St Teresa*.
Armstrong was fascinated by the altered states of
consciousness that could be achieved through prayer
and meditation, which he saw as related to Surrealist
inspired dream imagery.

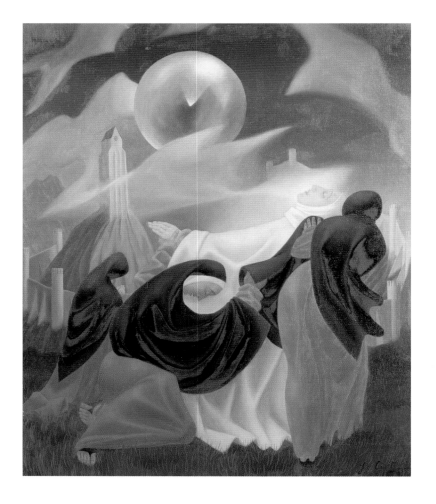

Revival and Survival

Kelly	Knight
Southall	Moody
Spencelayh	Symons
Glasson	Watson
Flint	Whitney-Smith
Brockhurst	Munnings
Downton	Robinson
Elwell	Orpen
Gunn	

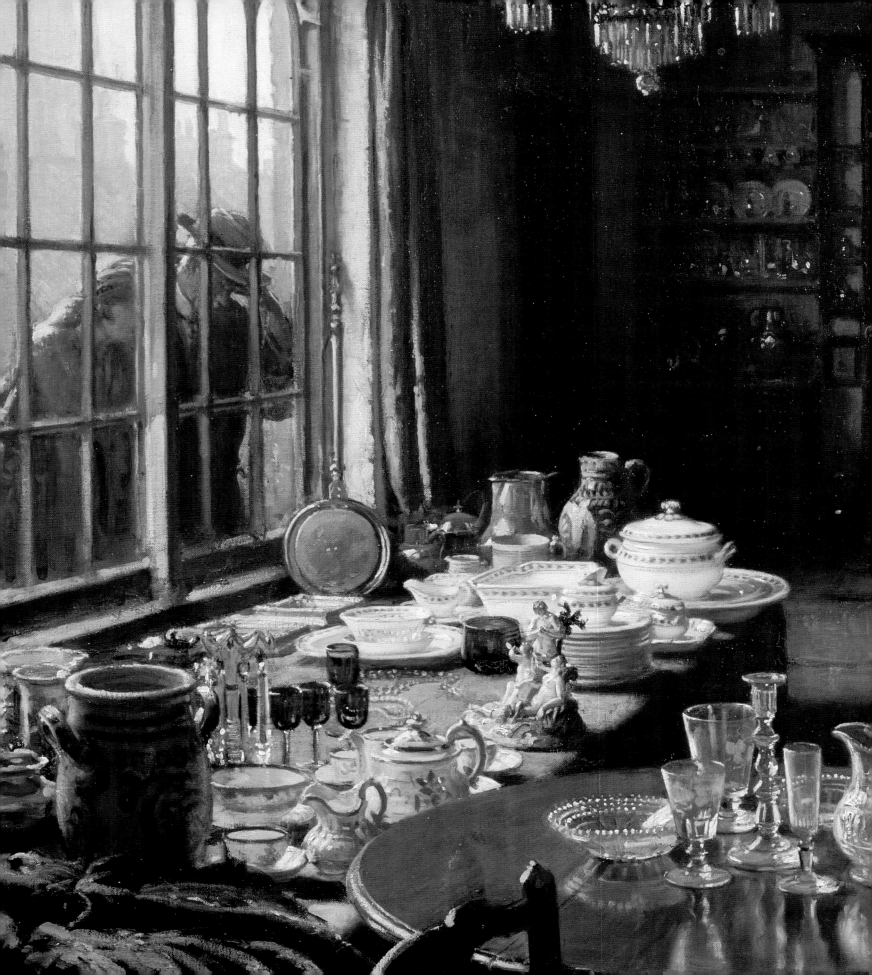

Revival and Survival

by Stephen Whittle

As an emphasis on purely formal values became the driving force behind the British avant-garde, storytelling or allusiveness in art increasingly came to be seen as reactionary and 'middle brow'. Not surprisingly academically trained artists reacted against the denigration of content in art and the suggestion that art rooted in material fact necessarily lacked inventiveness or intellectual significance.

Instead of breaking with the past, some artists attempted to renew or even re-invent traditional ways of working. Joseph Southall, for example, produced period figure compositions with a clear debt to early Renaissance art, perfecting the virtually lost art of tempera painting. *Along the Shore* (cat 125), painted in 1914, is based on direct observation of a specific location and carefully described details of contemporary costume. It is also rooted in long tradition. Painted in soft, luminous washes of egg tempera, its sense of fixity, the elegant lines of the figure group and the decorative treatment of the billowing scarves are all learned from the Venetian colourists such as Carpaccio and the graceful figure compositions of Benozzo Gozzoli.

Along with Walter Crane and William Holman Hunt, Southall had formed the Society of Painters in Tempera in 1901. By the 1930s Surrealists like Edward Wadsworth and John Armstrong were making extensive use of the medium, its precise, linear qualities helping to convey a De Chirico-like sense of alienation. At the same time tempera painting became a rallying point for artists reacting against the hegemony of Modernist art. As gestural and expressionist painting styles gained acceptance, the sense of detachment imposed by the physical properties of tempera attracted artists looking to reintroduce qualities of classical restraint and poise to their art.

The careers of John Downton and Victor Hume Moody represent a reaction not just against Modernist art, but against modern life in general. Downton exhibited a few works at the Royal Academy in the 1930s but quickly withdrew from the public arena, feeling his humanist values to be at odds with the materialism of the mid twentieth century.

Woman at the Window (cat 125) began as a naturalistic study from the model. Downton gradually refined and abstracted the composition through a long series of studies to achieve a synthesis of the Renaissance portrait format with his own highly individual creative vision. The resulting image has an iconic quality, a deeply personal expression of idealized beauty, and is a call to order in which the representation of the human figure is reinstated as the principal object of art.

In his critical writings Downton argued at great length that "the past holds the key to the re-orientation of the future". He shared with Victor Moody a respect for the writings of Ruskin and Morris, who had advocated a return to the medieval guild system. Moody established a School of Art in Malvern where the principles of craftsmanship in art and design were taught well into the 1960s, long after most art schools had dispensed with teaching technique.

Crossing the Brook (cat 126) was painted by Victor Moody in 1934. It has the purity of colour and clarity of line often associated with British Surrealist art of the 1930s but Moody had no interest in representing the sub-conscious or the irrational. Nor was he a symbolist or an allegorical painter, like other tempera painters of the day. In contrast to Downton's, Moody's paintings are carefully plotted, solidly realised compositions set within a contemporary landscape. Moody's work represents an ambitious extension of the classical tradition, fusing the direct observation of Pre-Raphaelite art with influences ranging as far afield as the sixteenth-century anatomical engravings of Vesalius, Piero della Francesca and seventeenth-century paintings of peasants by the Le Nain brothers. Downton and Moody are typical of a significantly large number of artists who were content to perfect their art in relative obscurity, their work known only to a small group of private patrons.

Rather than rejecting the modern world so completely, other artists were content to continue the nineteenth-century tradition of subject painting in a virtually unmodified form. Indeed Frederick Elwell was exhibiting successfully at the Royal Academy and the Paris Salon in the mid 1890s. Having flirted briefly with Impressionist painting techniques as a student, and in later life as a successful landscape painter, he developed a more fully modelled and tonally subdued style of painting in his portraits and genre scenes based on the example of seventeenth-century Dutch painting. *The Curiosity Shop* (cat 120), painted in 1929, is as much a still-life painting as a contemporary genre scene. A young couple peer in through the shop window as if looking at a tableau of the Victorian age. Both in subject and in style it is a deeply conservative image, and the romantic, wistful quality of Elwell's work made him a firm favourite with the British public.

The nostalgic evocation of bygone days was also the stock in trade of Charles Spencelayh. *A Lover of Dickens* (cat 119) is a typical example of his carefully staged interiors, in which elderly gentleman potter around reassuringly cluttered junk shops and jumble sales. Spencelayh was also an accomplished miniaturist and his highly finished rendering of objects helped to create images of self-absorption and cosy insularity. He nevertheless managed to catch the mood of the nation with *Why War?* (cat 127), painted in 1938 and a Royal Academy 'Picture of the Year' in 1939. Spencelayh injected an atypical note of pathos in this work, picturing a veteran of "the war to end all wars" sadly contemplating the onset of another global conflict. The narrative is skilfully fleshed out in the understated detail – a recently delivered gas mask from Lewisham Council, the old soldier's medals from Mons and other campaigns, the patriotic and pastoral prints which cover the walls.

Mark Symons's paintings represent a different form of retreat from the modern world. A Slade School student at the same time as Stanley Spencer, he shared with his better-known contemporary a deep religious faith, painting scenes from the life of Christ in modern dress and in local settings. He also expressed his faith in a number of intimate domestic scenes. *Molly in the Garden* (cat 128) is an image of childhood innocence in a self-contained suburban paradise. Our view is constrained by the sharply tilted backdrop of the artist's homely back garden. In their desire to make spirituality present in the everyday, Symons's and Spencer's art can perhaps best be seen as a late manifestation of the Pre-Raphaelites' ideological programme.

Tradition was as much a living force for curators as it was for artists in the first half of the last century. Galleries like the Harris in Preston continued to buy art works that complemented their imposing classical architecture and their collections of casts, replicas and Victorian genre paintings. The watercolourist William Russell Flint was very successful in casting his small-scale studies of the nude, often pictured on the beaches of the French Riviera, into a mould well suited to the tastes of municipal collectors. In *Artemis and Chione* (cat 123), bought by the Harris in 1931, the addition of a few props and a decorative forested background provided sufficient justification for its acquisition as a classical subject. In 1935 Flint's *Maruja the Strong* (cat 117), tenuously based on an obscure novel by Brett Hart, was added to Rochdale Art Gallery's collection of narrative paintings.

Paintings of the nude were contentious throughout the period and artists, critics and curators were often at pains to stress any links with tradition, no matter how slender. Sidney Paviere, the influential curator of the Harris from 1926 to 1959, began his career with one of his most controversial purchases, George Spencer Watson's *Nude* (cat 130). When the painting was bought in 1927, the national press reported at length on the objection of local councillors to its "indecent" character.[1] Paviere argued that fewer artists were now painting nudes and that "… if artists ceased to paint the nude figure they would cease to know how to do it".[2]

Rochdale's councillors shied away from the purchase of Lance Glasson's *The Young Rower* (cat 116), acclaimed by the press as the Royal Academy's 'Picture of the Year' in 1932. It was bought for just £120 by one of the councillors on their Art Gallery Committee, however, just ahead of a bid from Blackpool Corporation, and presented to the gallery later that year. The painting was so similar in style to Laura Knight's paintings of the female nude that it was rumoured to have been submitted by her to the summer exhibition under a pseudonym. Knight and Dod Procter had produced superficially similar images in the 1920s and early 1930s, in which women were portrayed with a boldly unselfconscious sensuality. In comparison, despite its cool tonality and what the *Sunday Times* reporter described as the model's "Degas-like pose", *The Young Rower* has a distinctly voyeuristic quality. As Sir Thomas Monnington, President of the Royal Academy in the 1960s, later recalled, "It looked chaste, but it was quite sexy really".

The curator at Oldham from 1904 to 1938 was W.H. Berry. Like Paviere, he believed that the standards of the past would continue to provide a yardstick for the future:

"Change in art is just a case of a fresh outlook. So what conforms to the best old traditions is likely to meet the artistic requirements for the future."[3]

Berry was a relatively adventurous patron, however, and early in the century a regular visitor to the New English Art Club, where he bought works by emerging artists, including Sickert, Orpen and McBey. *Behind the Scenes* (cat 129) by William Orpen was bought for Oldham for just £100 in 1910. It very clearly meets Berry's criteria for a traditional painting embodying a new outlook. The subtle tonality of the background reflects Orpen's careful study of Rembrandt, while the ambiguity of the subject and the understated air of suspense are reminiscent of turn-of-the-century interiors by fellow Slade School artist William Nicholson. Orpen was fascinated by the contrast between the glamour of the stage and the often seamy reality of backstage life. The similarity between the sinister figure of the male actor and Orpen's early self-portraits adds a personal dimension to this work, highlighting the contrast between the illusion of art and the reality it purports to represent.

Orpen was the most successful and sought-after portrait artist of his generation. He painted over six hundred commissioned works, including some outstanding portraits, but also many that were uninspired and formulaic. Alfred Munnings painted well over three hundred commissions during the 1920s and 1930s, and admitted quite frankly, "I only painted them to make money …", hoping that posterity would judge him by his scenes of country life.[4] Yet even a fairly routine horse portrait like *Solario* (cat 132) has a freshness of colour and qualities of light and movement that places Munnings alongside great British equestrian artists such as J.F. Herring and George Stubbs.

To avoid compromising the quality of his commissioned work, Gerald Leslie Brockhurst eventually limited himself to twenty portraits a year. Celebrities such as Marlene Dietrich, the Duchess of Windsor and J. Paul Getty were prepared to pay over 1000 guineas for a portrait that could invest them with something of the style and elegance of *Dorette* (cat 118), one of the key works in establishing Brockhurst's reputation.

Brockhurst used overtly Italianate settings for his portraits, often working in tempera and making direct reference to the paintings of Leonardo Da Vinci and Botticelli. The distinctive and 'modern' quality of a painting such as *Dorette* lay in its highly finished surface, imparting a photo-realistic glamour to this idealized image of womanhood. At once classically remote and sensual, *Dorette* was the hit of the 1933 Royal Academy exhibition. Sidney Paviere only just managed to buy it for the Harris, minutes ahead of a bid from Lord Leverhulme, who wanted it for his collection at Port Sunlight.

In the 1940s representational painters could still make front-page news and Paviere had no qualms about buying work that was broadly popular:

" … a public gallery must make some attempt to satisfy its visitors. Otherwise it is likely to be a sanctum visited only by a few interested members of the artist's profession."[5]

This was said in defence of his purchase of *Pauline in the Yellow Dress* (cat 124) by James Gunn, described by the Daily Mail as "a Mona Lisa of 1944". Like Brockhurst and Gerald Kelly, Gunn regularly used his wife as a model in portraits that demonstrated his prowess to potential patrons at the Royal Academy, openly incorporating art historical references in these works. Gunn's portraits elicited comparisons with the work of Velázquez, though the similarities are in the composition rather than in the handling of paint. Whereas Velázquez's brushstrokes are often clearly visible, Gunn's paint is very thinly and carefully applied. In a telling exchange, Gerald Kelly, jealous of Gunn's success, described *Pauline in the Yellow Dress* as "cheap and photographic". Incensed, Gunn replied, "The bastard, he'd be lost without his Leica". Certainly both artists were more interested in the perfection of the image and a slick surface realism rather than the innately expressive qualities of paint.

The great society portrait painters of the 1930s and 1940s brought representational painting to a peak of technical perfection but theirs was a relatively superficial adaptation of tradition. There were many more artists who were genuinely inspired by the achievements of the past. But, whether famous or obscure in their own time, artists outside the avant-garde now rarely feature in histories of the period. Though they are unlikely ever to regain a central place in the history of art, it is impossible to gain anything like a complete picture of British twentieth-century art without some consideration of the academic mainstream.

1. *The Daily Express*, 28 May 1927; *The Daily Herald*, 28 May 1927.
2. *Lancashire Daily Post*, 27 July 1927.
3. *Oldham Chronicle*, 13 April 1938.
4. Nicholas Usherwood, *Alfred Munnings 1878–1959*, exh. cat., Manchester City Art Gallery, 1986, p. 6.
5. *Preston Guardian*, 6 May 1944.

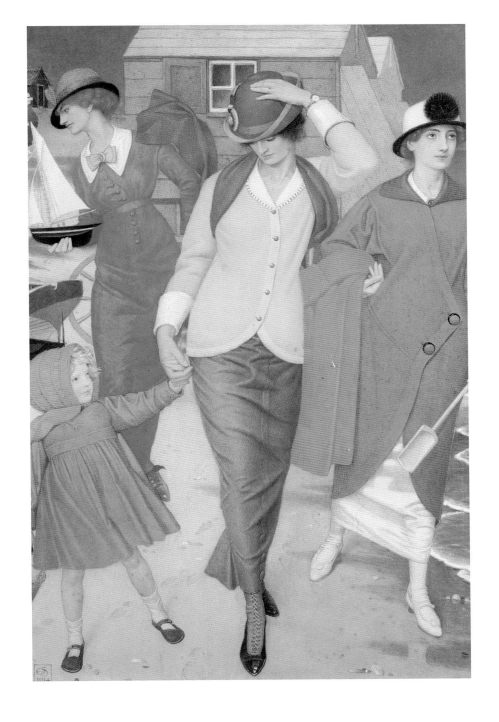

115

Joseph Southall
(1861–1944)

Along the Shore, 1914
Tempera on silk
117 x 81 cm

This painting was bought for just 60 guineas when it was exhibited at the Oldham Spring Exhibition of 1920. Southall's combination of modern and classical references was not widely popular. The *Times* reporter felt that his "goddesses are more convincing in their fairy-tale charades than when they strike the same attitudes in Edwardian clothes in *Corporation Street, Birmingham* or *Along the Shore*" (quoted in *Joseph Southall*, exh. cat., Birmingham Museum and Art Gallery, 1980).

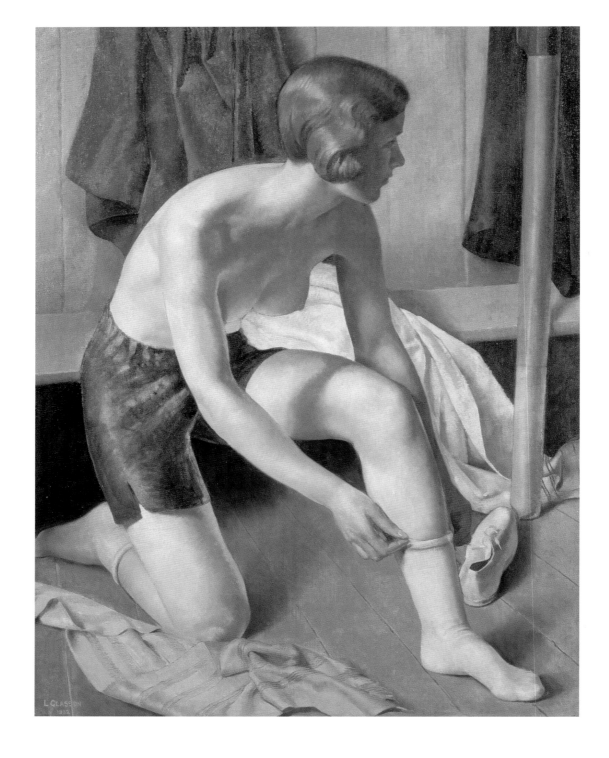

116

Lance Glasson
(1894–1950)

The Young Rower, 1932
Oil on canvas
102 x 76 cm

This picture was exhibited in the Royal Academy's newly designated Modern Room in 1932, where it caught the eye of critics from the national press. Glasson vainly attempted to repeat his success in subsequent years with another rowing subject, *The Four*, and *The Swimmer*, both using the same model.

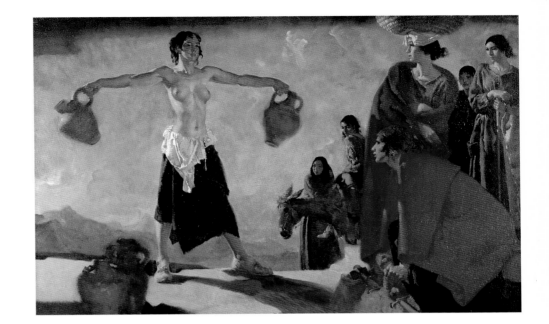

117

William Russell Flint
(1880–1969)

Maruja the Strong, c. 1935
Oil on canvas
87 x 137.5 cm

118

Gerald Leslie Brockhurst
(1890–1978)

Dorette, 1933
Oil on panel
61 x 49.5 cm

Brockhurst was an accomplished etcher and *Dorette* first
appeared, in 1932, as an etching. The model, Kathleen
Woodward, posed for Brockhurst's best-known etching,
Adolescence, that same year. There was much press
scandal about the artist's 'Svengali-like' influence over
his youthful model. He convinced her to change her
name to Dorette and she eventually became his second
wife.

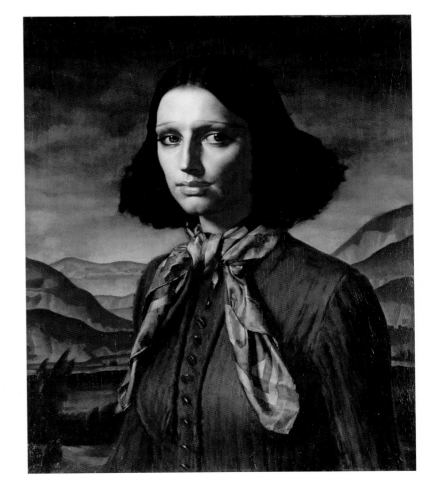

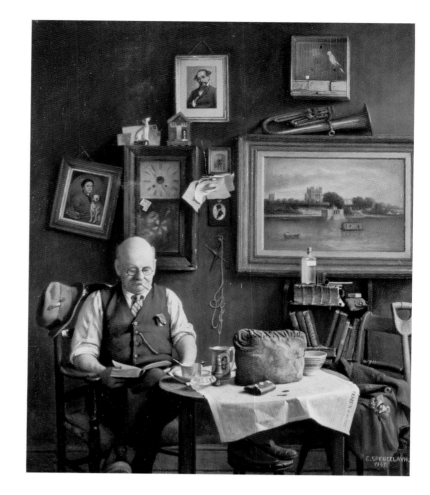

119

Charles Spencelayh
(1865–1958)

A Lover of Dickens, 1947–48
Oil on canvas
57.6 x 48 cm

120

Frederick William Elwell
(1870–1958)

The Curiosity Shop, 1929
Oil on canvas
102.5 x 128 cm

This is one of Elwell's many paintings of Beverley, his
home town. The Minster is visible in the background and
the couple looking through the window are the artist and
his wife.

121

Gerald Kelly
(1879–1972)

Burmese Dancer IV, 1919–20
Oil on canvas
117 x 81 cm

Kelly's Royal Academy exhibits of temple dancers,
following his visit to Burma in 1908, were very popular.
Both Oldham and Rochdale art galleries have similar
examples. Kelly was in great demand as a portrait
painter but also exhibited Impressionistic landscapes
and seascapes. He succeeded Munnings as President
of the Royal Academy in 1949.

122

Harold Knight
(1855–1918)

Girl reading, 1932
Oil on canvas
46.2 x 50.5 cm

Knight was very influenced by seventeenth-century
Dutch painters of domestic interiors. The stillness and
calm of this work, the attention to textural detail and the
fall of light, are reminiscent of Vermeer's paintings of
young women.

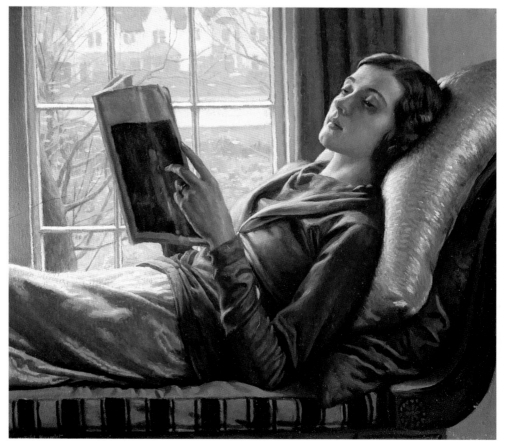

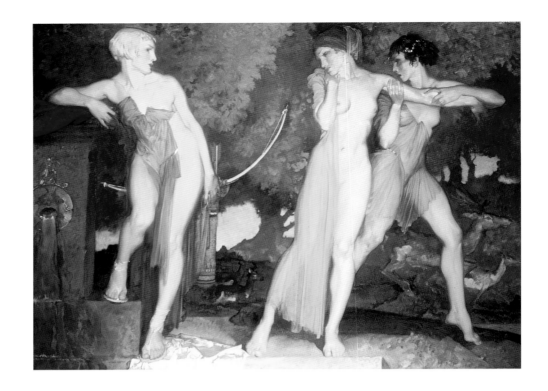

123

William Russell Flint
(1880–1969)

Artemis and Chione, 1931
Oil on canvas
106.5 x 147.5 cm

Russell Flint is best known as a watercolourist. He was a
superb draughtsman and his watercolour washes
combine apparent ease with close control. Most
municipal galleries preferred to buy his landscapes
rather than the endlessly reproduced nudes for which he
became famous. A full Academician, he also became
President of the Royal Watercolour Society.

124

Herbert James Gunn
(1893–1964)

Pauline in the Yellow Dress, 1944
Oil on canvas
127 x 101.5 cm

Honours came late in Gunn's life: he became a full
Academician only in 1961 and was knighted in 1963.
Amongst his best-known works are a portrait of
George VI with his family and a conversation piece
featuring the three writers G.K. Chesterton, Hilaire Belloc
and Maurice Baring (both paintings are in the National
Portrait Gallery).

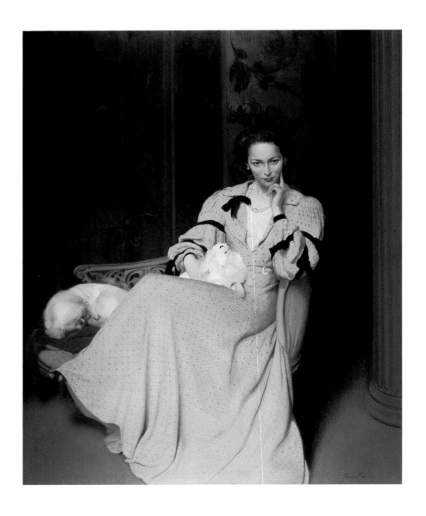

125

John Downton
(1906–1991)

Woman at the Window, c. 1934
Tempera on mahogany panel

The composition is probably based on Fra Filippo Lippi's *Madonna and Child* in the Uffizi (*John Downton*, exh. cat., Maas Gallery, London, 1996, p. 52). In the late 1930s Downton moved to Florence, where he bought a number of Renaissance frames for his paintings.

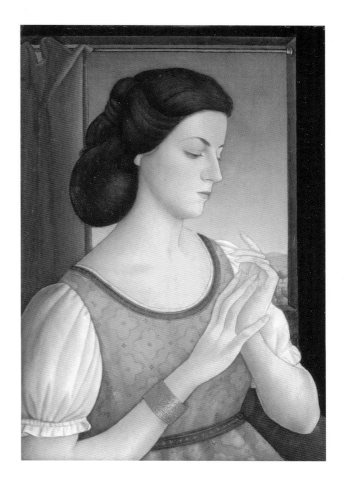

126

Victor Hume Moody
(1896–1990)

Crossing the Brook, 1934
Oil on panel
49.5 x 42 cm

At odds with the direction of post-war art, Victor Moody gave up his career as a portrait painter in 1922 and bought a farm instead. He was persuaded to enrol in the Royal College of Art in 1925, where he studied life drawing intensively and was introduced to figure compositions and the art of mural painting by William Rothenstein. He subsequently established a School of Art in Malvern, where students studied silversmithing, bookbinding and other crafts, as well as having the opportunity to explore traditional picture-making techniques

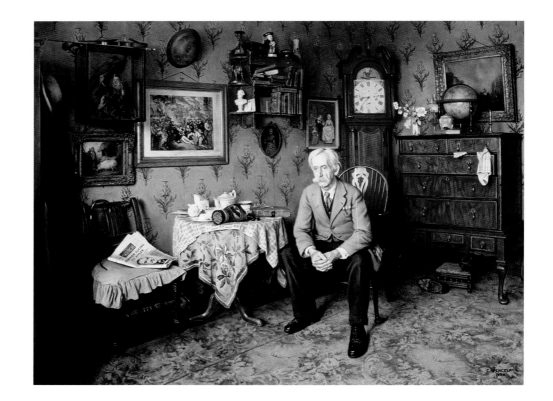

127

Charles Spencelayh
(1865–1958)
Why War?, 1938
Oil on canvas
71 x 91.5 cm

128

Mark Lancelot Symons
(1887–1935)
Molly in the Garden, 1930
Oil on panel
54.5 x 36.9 cm

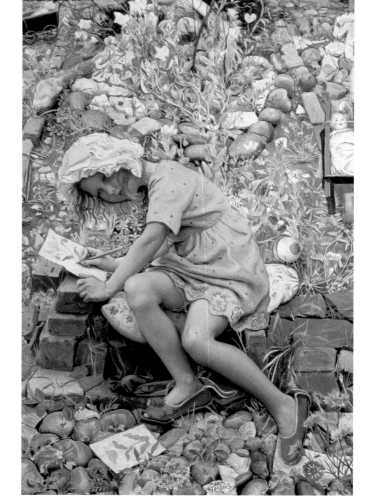

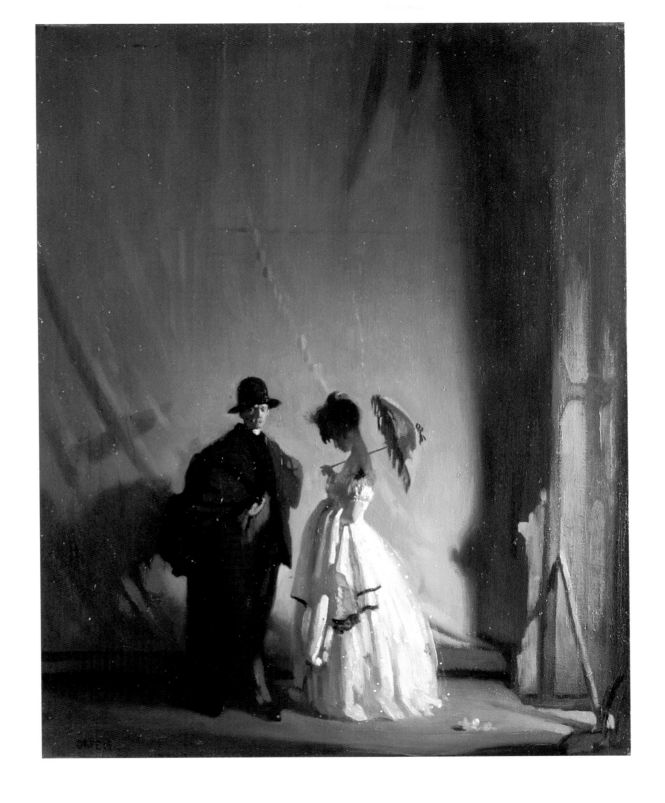

129

William Orpen
(1878–1931)
Behind the Scenes, 1910
Oil on canvas
92 x 72 cm

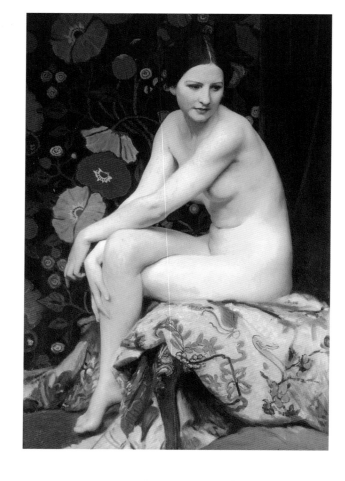

130

George Spencer Watson
(1869–1934)
Nude, 1927
Oil on canvas
117 x 81.5 cm

On his death in 1934, Spencer Watson's obituary in *The Daily Mail* carried the headline "'Nude' Controversy". He was otherwise largely unknown, except as a competent portrait painter and an Associate Royal Academician.

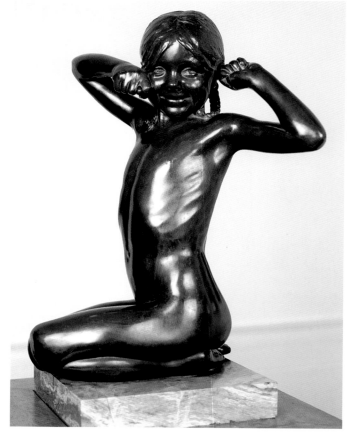

131

Edwin Whitney-Smith
(1880–1950)
The Awakening, 1911
Bronze
69 cm

132

Alfred Munnings
(1878–1959)

Solario, c. 1925
Oil on canvas
106 x 89 cm

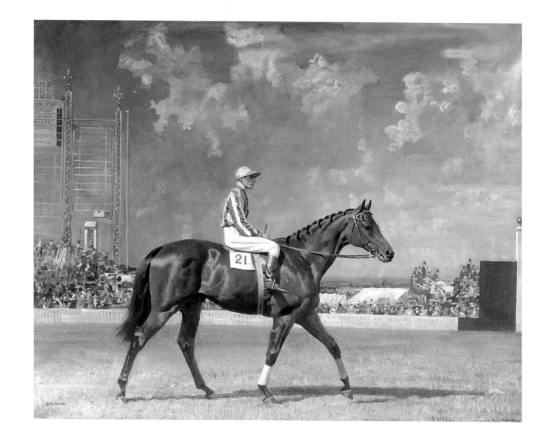

133

Frederick Cayley Robinson
(1859–1929)

The Day of Rest, 1926
Watercolour on paper
31.5 x 50.5 cm

Cayley Robinson's watercolours and tempera paintings are marked by an understated symbolism. The subject is often unclear and certainly of less importance than the evocation of a mood of reverie, as with Burne Jones's later figure compositions and the timeless classical idylls of Puvis de Chavannes, which he admired.

Index

Contributing Galleries:

Gallery Oldham: 1, 2, 3, 4, 15, 16, 17, 18, 26, 27, 28, 29, 30, 31, 32, 37, 38, 39, 40, 41, 42, 43, 44, 45, 58, 59, 60, 61, 62, 63, 64, 71, 86, 87, 88, 89, 90, 91, 93, 94, 95, 96, 97, 98 99, 100, 101, 102, 115, 119, 121, 129

Harris Museum & Art Gallery, Preston: 7, 8, 9, 10, 11,12, 24, 33, 34, 35, 55, 56, 57, 77, 78, 79, 80, 81, 82, 83, 111, 113, 114, 118, 120, 122, 123, 124, 125, 126, 127, 128, 130, 131

Bolton Museum and Art Gallery: 6, 52, 53, 54, 66, 72, 73, 74, 75, 76. 92, 103, 104, 105, 106, 107, 108, 109

Touchstones, Rochdale: 5, 19, 20, 21, 22, 23, 46, 47, 48, 49, 50, 51, 65, 67, 68, 69, 70, 116, 117

Grundy Art Gallery, Blackpool: 8
Blackburn Museum and Art Gallery: 13, 132
Bury Museum and Art Gallery: 25, 110, 112, 133
Atkinson Art Gallery, Southport: 14, 36, 85

Picture Credits